SKETCH BY SKETCH

Along Nova Scotia's South Shore

EMMA FITZGERALD

FORMAC PUBLISHING COMPANY LIMITED
HALIFAX

To Madeline & Myra, who have grown up amongst boats and blossoms, and yurts and yard sales, sharing the shore with me.

Design: Tyler Cleroux

Library and Archives Canada Cataloguing in Publication

FitzGerald, Emma, 1982-, author, illustrator
 Sketch by sketch along Nova Scotia's South Shore / Emma Fitzgerald.

ISBN 978-1-4595-0476-9 (hardcover)

 1. South Shore (N.S. : Region)--In art. 2. South Shore (N.S. : Region)--History. I. Title.

FC2345.S68F58 2017 971.6'2 C2017-903278-X

Formac Publishing Company Limited
5502 Atlantic Street
Halifax, Nova Scotia, Canada
B3H 1G4
www.formac.ca

Printed and bound in China.

Formac Publishing Company Limited recognizes the support of the Province of Nova Scotia through the Department of Communities, Culture and Heritage. We are pleased to work in partnership with the Province of Nova Scotia to develop and promote our cultural resources for all Nova Scotians. We acknowledge the support of the Canada Council for the Arts, which last year invested $153 million to bring the arts to Canadians throughout the country. This project has been made possible in part by the Government of Canada.

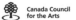

to the French Shore

YARMOUTH

TUSKET

to Maine

EAST PUBNICO

BIRCHTOWN

SHELB[

WOODS HARBOUR

ST. MARGARET'S BAY

HUBBARDS

to Halifax

GOLD RIVER

CHESTER

BLANDFORD

PEGGY'S COVE

POLLY COVE

BRIDGEWATER

MAHONE BAY

BIG TANCOOK ISLAND

LONG ISLAND

BLUE ROCKS

LUNENBURG

SECOND PENINSULA

LAHAVE

RIVERPORT

KINGSBURG

WEST DUBLIN

GAFF POINT

UPPER KINGSBURG

WEST IRONBOUND ISLAND

PORT MEDWAY

EAST BERLIN

LIVERPOOL

PORT MOUTON

KEJIMKUJIK NATIONAL PARK (seaside adjunct)

LOCKEPORT

N NE NNE
NW NNW
W E
SW SE
SSW S SSE

Introduction

I have lived in Halifax for the past twelve years. My first visits to the South Shore were like furtive crab movements, scuttling down for a quick trip to Peggy's Cove or Lunenburg with visiting guests, quickly returning to the city. I stuck to the road map, and didn't know anyone in these places.

Over the years, my ties to the province strengthened, and my knowledge of places improved. However, it was only in the undertaking of this project that I really embraced what the South Shore has to offer. The experience of drawing on location has created a sense of places and people that is truly unique. I know that I am only scratching the surface of what is there, which makes it all the more fascinating.

I coloured my sketches at home on a computer. One day while working, I was listening to the Tragically Hip song "Putting Down." I heard Gord Downie's words:

There's reasons for the road I guess
To document the indigenous
To paint and sketch, paint and sketch
I'm starting to fail to be impressed

So many of the European settlers who came to this area failed to forge a relationship with the First Nations people already living here. They were painted and sketched, but not treated humanely. The repercussions of this can still be felt. I hope my sketching can elicit some of the humanity that we all are in such need of. In that spirit, I offer thanks to the Mi'kmaw people and other indigenous nations who have inhabited these lands, and acknowledge that this beautiful province is unceded Mi'kmaw territory.

SPRING

Spring is a long time
coming on the South
Shore, but finally, the
leaves start to bud and
the daylight extends later
into the evening. We start to
live life in a way that tries to
approximate summer — going
outside more for day trips, and
wanting to have an after-dinner
stroll. From experience, I know
not to go far without a sweater,
no matter the forecast. Everyday
practicalities beckon, like spring
cleaning and clearing land, and
many people on the South Shore are
getting ready for summer tourists.

The popular tourist destination Peggy's Cove has a nearby cousin, Polly Cove. It is accessed from a trail just off Highway 3, the old road that winds down the South Shore, hugging the ocean.

Depending on the time of year, open-toed shoes may or may not be advisable, but on a May day I am finally almost able to go barefoot.

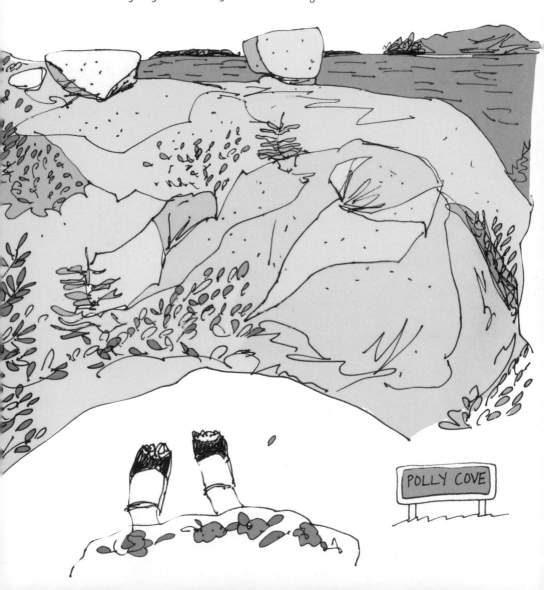

POLLY COVE

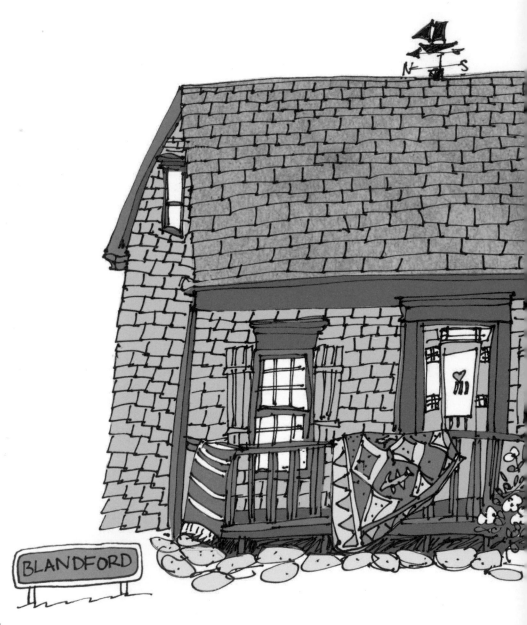

BLANDFORD

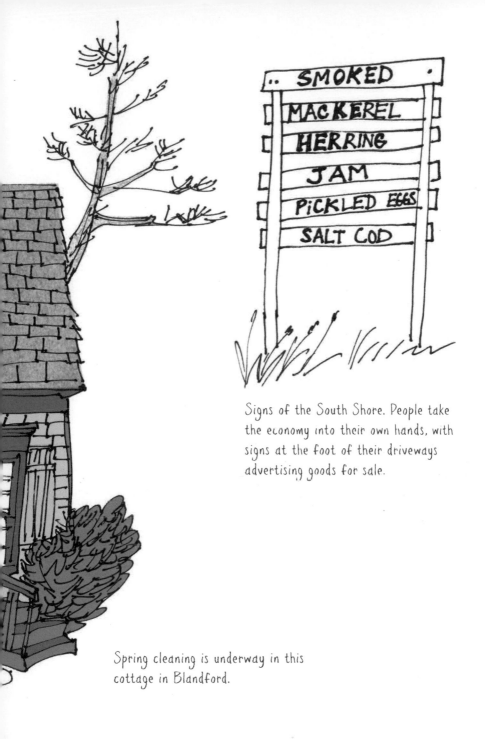

Signs of the South Shore. People take the economy into their own hands, with signs at the foot of their driveways advertising goods for sale.

Spring cleaning is underway in this cottage in Blandford.

House for sale on Pleasant Street in Chester. It does not come with a cat, but it does include an inn and restaurant located just next door.

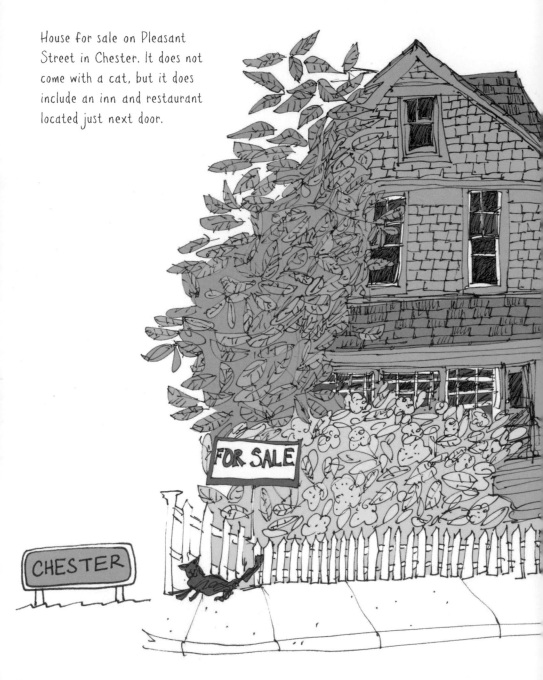

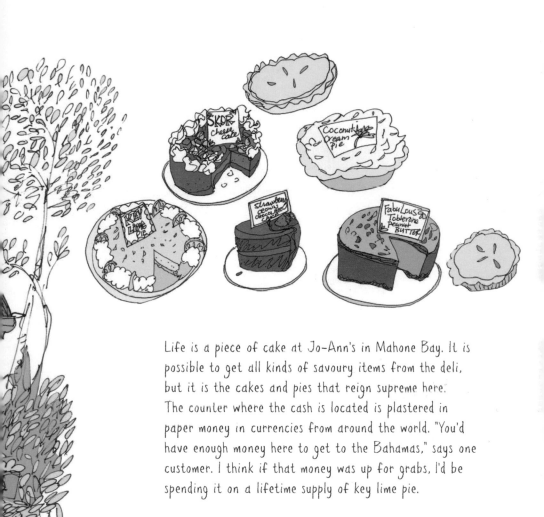

Life is a piece of cake at Jo-Ann's in Mahone Bay. It is possible to get all kinds of savoury items from the deli, but it is the cakes and pies that reign supreme here. The counter where the cash is located is plastered in paper money in currencies from around the world. "You'd have enough money here to get to the Bahamas," says one customer. I think if that money was up for grabs, I'd be spending it on a lifetime supply of key lime pie.

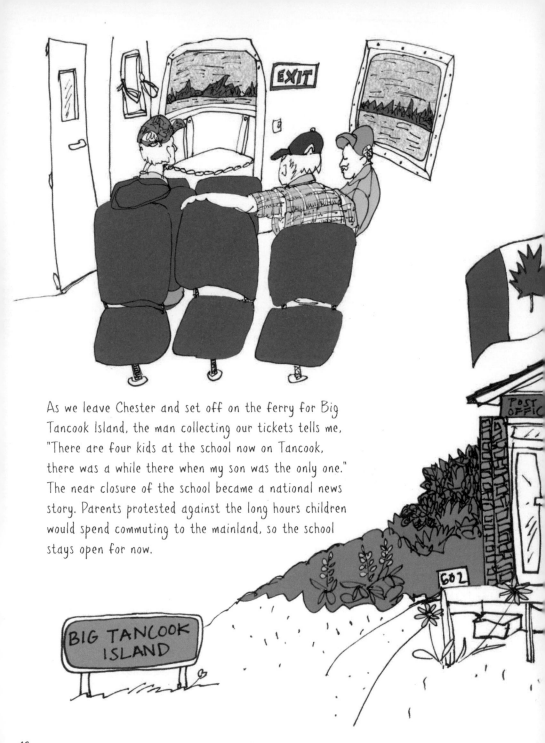

As we leave Chester and set off on the ferry for Big Tancook Island, the man collecting our tickets tells me, "There are four kids at the school now on Tancook, there was a while there when my son was the only one." The near closure of the school became a national news story. Parents protested against the long hours children would spend commuting to the mainland, so the school stays open for now.

OOK ISLAND BUREAU DE POST

CANADA POST
TANCOOK ISLAND

MAIL

BIG TANCOOK ISLAND ELEMENTARY SCHOOL

The brightly coloured chairs outside of
Carolyn's Café on Big Tancook Island are
a clever invitation directed at tourists
coming off the ferry, coaxing them to
come in and dine on fish and chips, rent
bikes and browse crafts. Late in the
day on a Saturday, it is several locals
who sit around a table. They discuss the
practicalities of destroying a home, on
an island fast losing its population. Their
voices carry the lilt of those who've lived
on the island for many generations.

"Well I don't know," says one.

"Well I don't know either."

"Well, if there is one thing I do know, you
can't just burn a building down, you've got
to take it apart first, but you'll make a
right mess doing that."

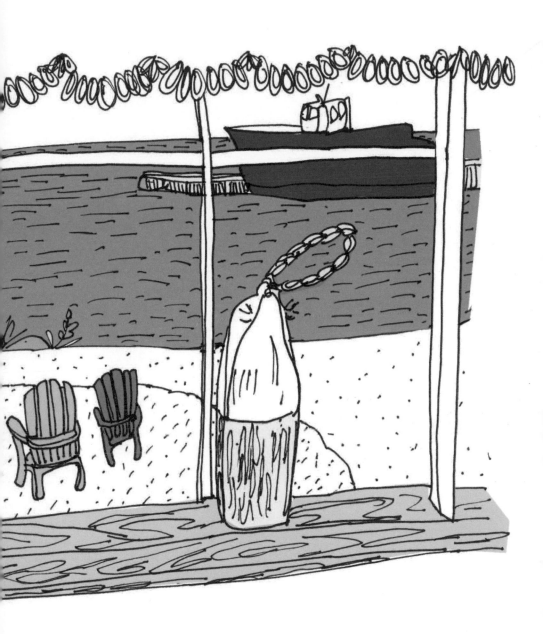

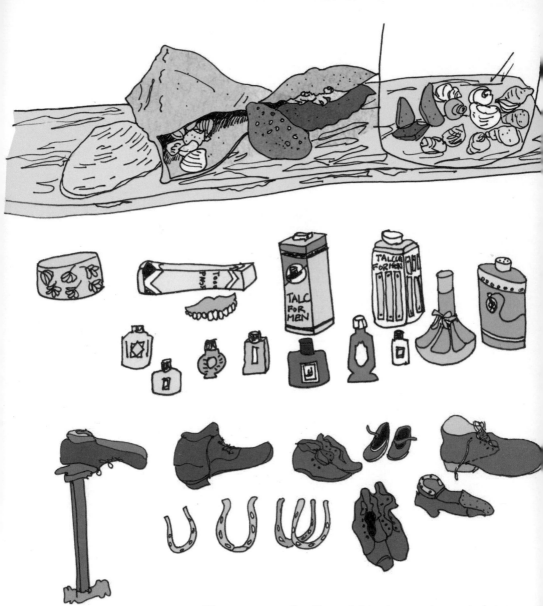

The museum on Big Tancook Island started in a shed, but now fills the former General Store and features curiosities from the island's past. Unlikely objects sit side by side: fake teeth and men's talcum powder, seashells and shoe soles with horseshoes for heels.

Looking out to the ocean through the grass path at Bachman's Beach has a new significance after speaking to Watsi Knickle. He came upon me drawing on the side of the road:

"What are you doing, counting trees?"

"Nope, drawing them."

He watches me intently, then tells me about how he lost his fingers; they froze at sea when he was sixteen, working on a fishing boat. He went right back on the ocean, working on boats in Labrador. Despite his injury, he makes finely crafted model boats for Adams & Knickle Ltd. in Lunenburg.

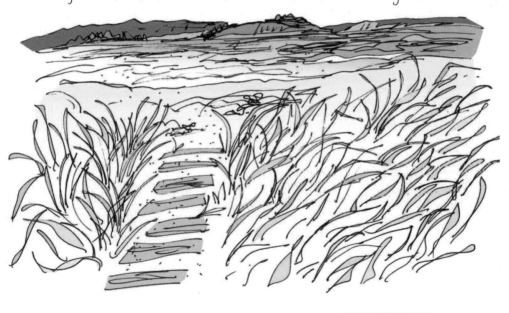

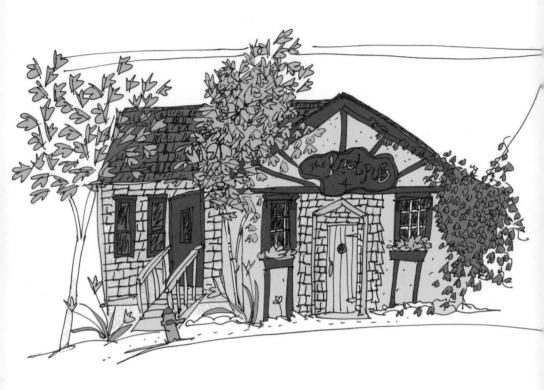

Two establishments in Lunenburg, the Knot Man and the Knot Pub, are not to be confused. The former occupies a few feet of the waterfront, selling his intricately made wares. The latter is the best place to find yourself on a rainy day. There you can eat a Knot burger, a delicious tribute to the town's German beginnings, featuring Lunenburg sausage with locally made sauerkraut, dill pickle and your choice of honey, dijon or mild mustard.

SAUERKRAUT RECIPE

INGREDIENTS:

- 1 medium head of cabbage
- 1-3 tbsp sea salt

INSTRUCTIONS:

1. Chop or shred cabbage. Sprinkle with salt.
2. Knead the cabbage with clean hands for about ten minutes, until there is enough liquid to cover.
3. Stuff the cabbage into a quart jar, pressing the cabbage underneath the liquid. If necessary, add a bit of water to completely cover cabbage.
4. Cover the jar with a tight lid.
5. Culture at room temperature (15-20°C is preferred) for at least two weeks until desired flavour and texture are achieved. If using a tight lid, burp daily to release excess pressure.
6. Once the sauerkraut is finished, put a tight lid on the jar and move to cold storage. The sauerkraut's flavour will continue to develop as it ages.

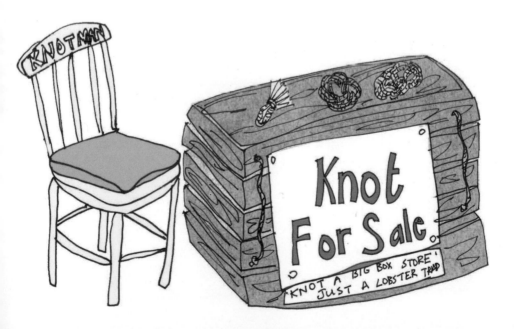

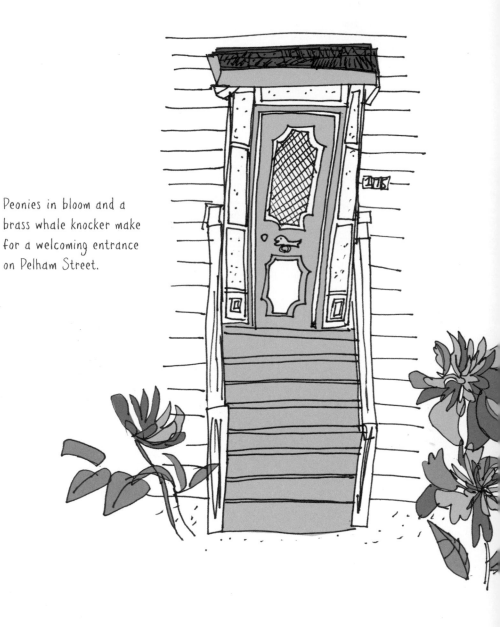

Peonies in bloom and a brass whale knocker make for a welcoming entrance on Pelham Street.

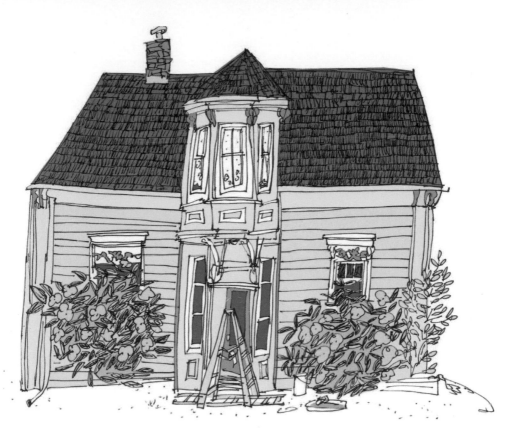

A woman stops to watch me draw a house on Hopson Street with a Lunenburg bump, the distinct protruding window over the door so characteristic of the town's heritage buildings. It is currently undergoing a paint job.

"There are three different types of houses here in Lunenburg," she says. "Those that have just been painted, those that are being painted and those that need to be painted." She watches me draw for a little longer.

"So you are an artist are you? My son is an artist. He is really good. He moved to Toronto, he has a studio there. He'll work on a painting for a whole year, and try to sell it for $3,000. But who has $3,000 for a painting these days?" I hear both the love and the worry mixed up in her voice.

"Yeah, I can see the food was awful," says a server to a table full of people with empty plates at Magnolia's Grill. "Anyone got any room for dessert? A lemon cheesecake? Sure, coming right up!"

Next door one can peruse books at Elizabeth's Books, one of three independent bookstores on the main drag in Lunenburg. Elizabeth's caters to the after-dinner crowd, only opening in the evening.

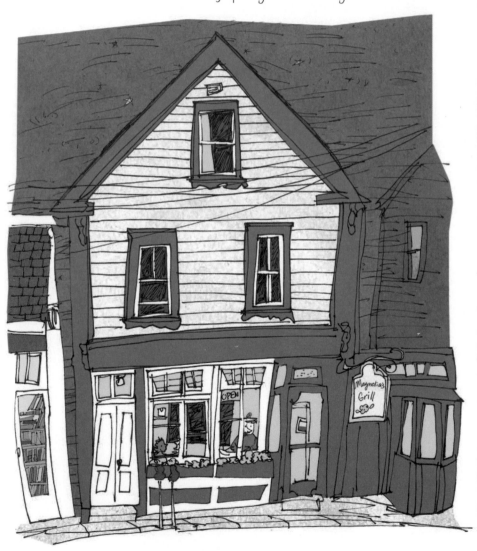

An off-duty server checks her
phone during a break.

BAILLY'S FUELS LTD.
HEATING FUELS · MARINE

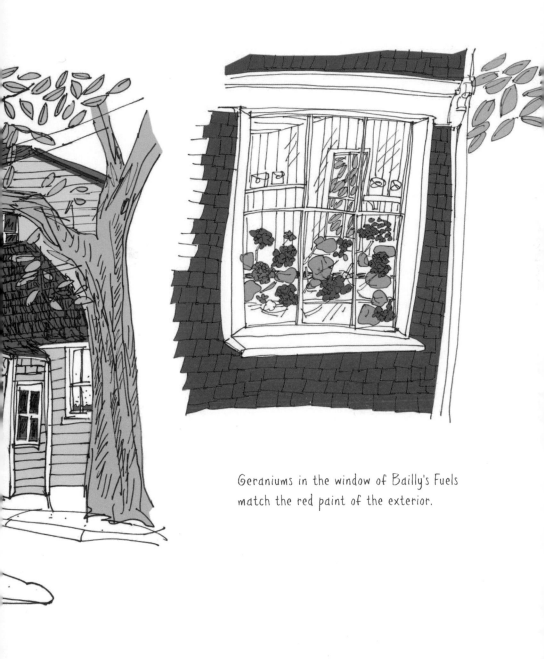

Geraniums in the window of Bailly's Fuels
match the red paint of the exterior.

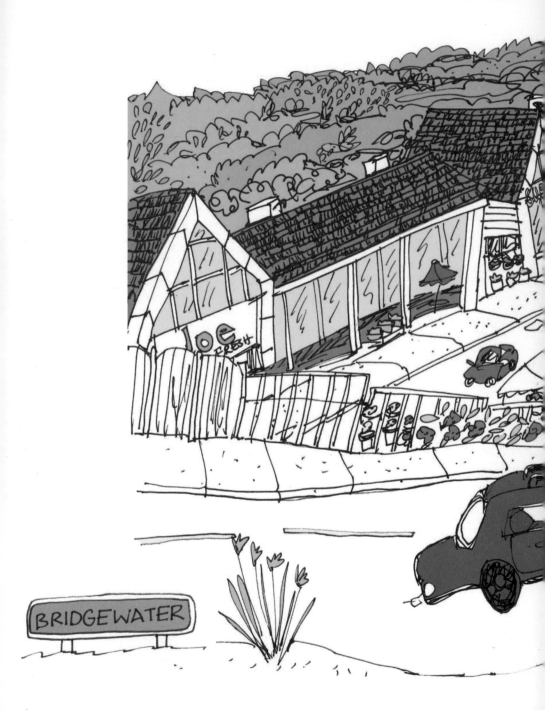

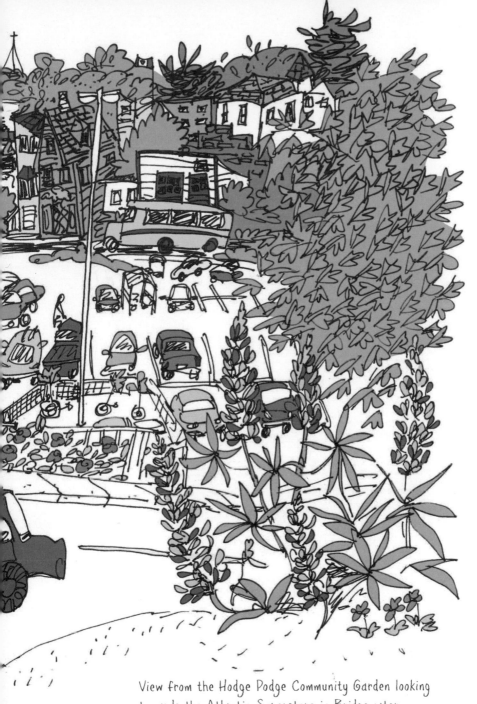

View from the Hodge Podge Community Garden looking towards the Atlantic Superstore in Bridgewater.

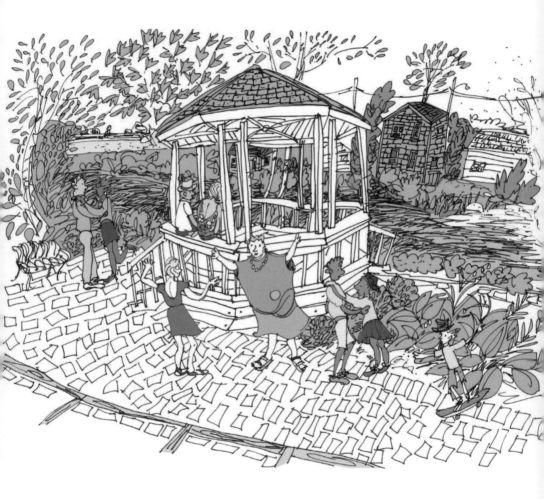

Salsa dancing and exercise classes happen in warmer months along the LaHave River in Bridgewater, bringing people together around the gazebo. The fountain in the river creates a refreshing spray.

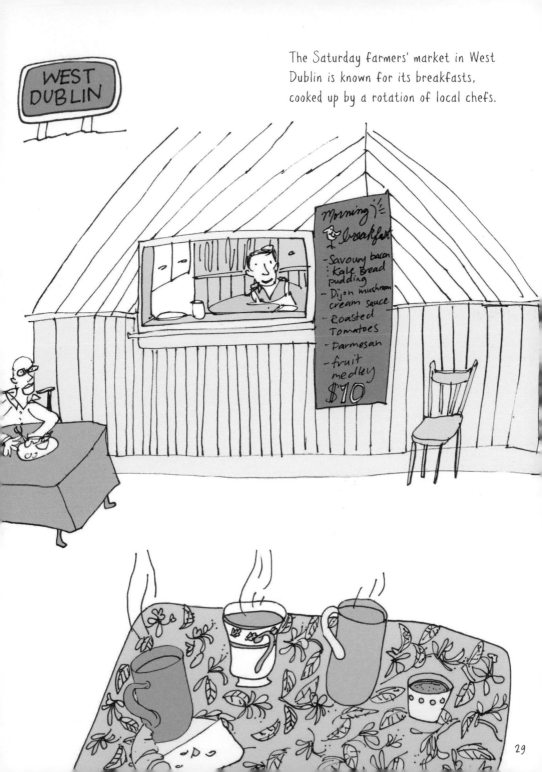

The Saturday farmers' market in West Dublin is known for its breakfasts, cooked up by a rotation of local chefs.

WEST DUBLIN

Morning Breakfast

- Savoury bacon
- Kale Bread pudding
- Dijon mushroom cream sauce
- Roasted Tomatoes
- Parmesan
- fruit medley

$10

I go to the Museum of Natural History in Halifax to talk with Roger Lewis, a Mi'kmaw man and ethnological curator for the museum. "So I am writing a book about the South Shore and I'd like to include Mi'kmaw perspectives . . ."

He pulls out maps and starts to describe watersheds in Nova Scotia, for example the Mersey River and the stone weir system that was used to harvest fish from it, and how other harvesting plans were used in different areas of the provinces, such as Antigonish. Though nowhere near the South Shore, his starting point leads me in the right direction.

Rivers, like cultures, are living systems, and to look at only one place on the map would ignore the complexity and interrelatedness of the Mi'kmaw cultural landscape.

Then he tells me the tale of Kitpooseagunow, who visited the lodge of *Noogmee*, his grandmother. He asked if she would make him a small canoe that he needed to complete his journey. He travelled many streams and rivers with it . . .

Later, as I sit by the Tusket River and sketch, I think of the stories, living and forgotten, that course through these waters.

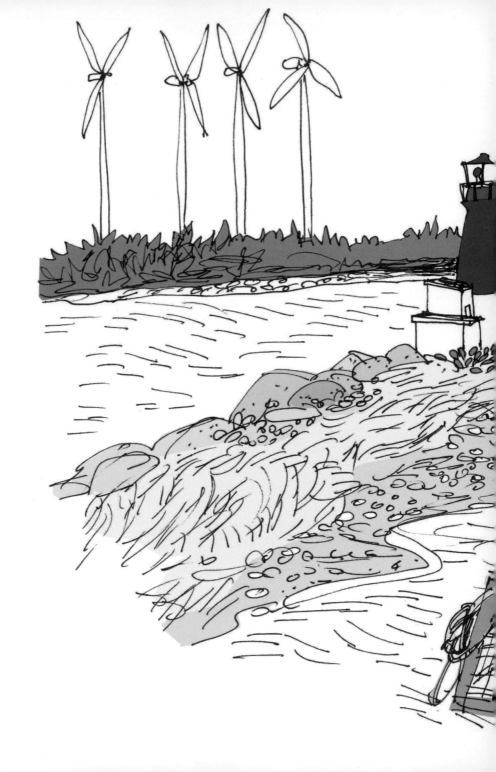

As I try to find the way to the lighthouse in Lower East Pubnico with a friend, patiently driving me despite her baby's wails, we momentarily get lost in Tusket. Signs in French whiz by, advertising the lottery game Chase the Ace and community suppers in church basements. The Acadian landscape surrounds us, marsh and farms on all sides. We stop at Carl's Convenience Store and get directions. We come to the lighthouse as the sun is setting. Across the water, wind turbines stand still. I sit and sketch. Behind me I hear the roar of dirt bikes; a local group of teenagers have shown up and soon leave, perhaps not used to having a baby and *plein-air* sketcher in their hang-out spot.

Building the Black Loyalist Heritage Centre has been a long road for descendants of the early Black Loyalist settlers in Birchtown. The museum opening was celebrated with a concert and dance in Shelburne in June 2015, a sign of times changing. In 1785 "Negro frolics and dances" were banned, and those who disobeyed were jailed.

The site has become synonymous with author Lawrence Hill's novel and subsequent mini-series, *The Book of Negroes*. I visit the centre with activist and journalist Desmond Cole, who is writing a book about his experience of being black and Canadian. He is trailed by a film crew as he does his research. His work bears witness to the oppression that people of colour still unfortunately continue to experience in Canada.

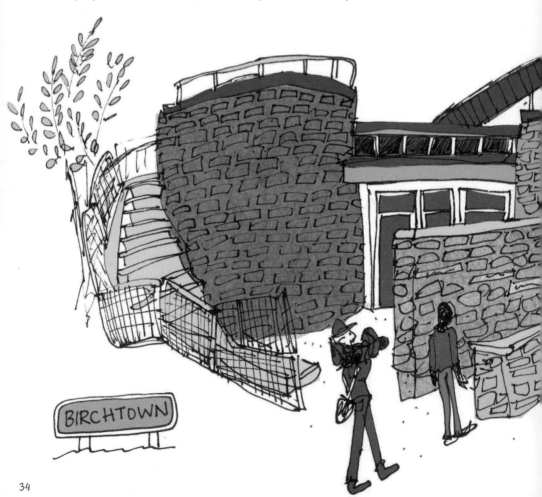

BIRCHTOWN

Desmond was born in Canada, but his parents emigrated from Freetown, Sierra Leone — the landing point for the many Black Loyalists who chose to leave Nova Scotia in 1792. At the museum he meets Jason Farmer, a ninth generation Black Loyalist, descended from the first settlers in Birchtown. Between the two men sits a photocopied version of the original Book of Negroes, a document from 1783 listing the former slave owners and other details about almost 3,000 'freed' slaves living in Nova Scotia at that time. "Do you have any questions?" asks Jason. "Yeah, like a million," says Desmond. Upon entering the exhibit, visitors are confronted with the names contained within the book, inscribed on the walls and floors; the building acts as a repository for their histories.

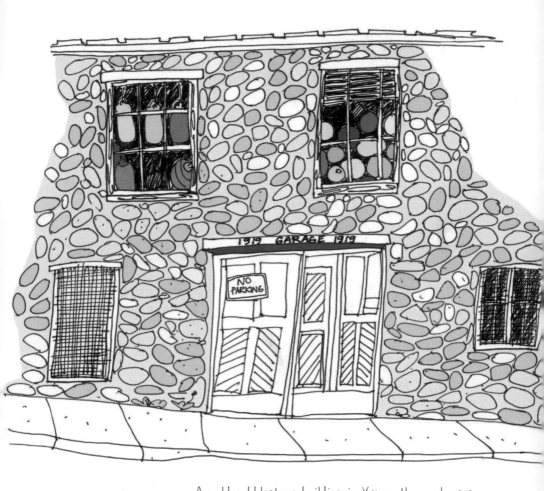

An old cobblestone building in Yarmouth now houses
Waterview Machine Works, but circa 1919 it was the
largest and most modern car garage in the Maritimes,
selling Ford and Studebaker vehicles. The stones bulge
like jelly beans bleached in the sun, and the candy theme
continues with the colourful fishing gear featured in the
window. Latin music can be heard at the nearby Shanty
Café, specializing in authentic Cuban, Indian and local
cuisine, warming a chilly day.

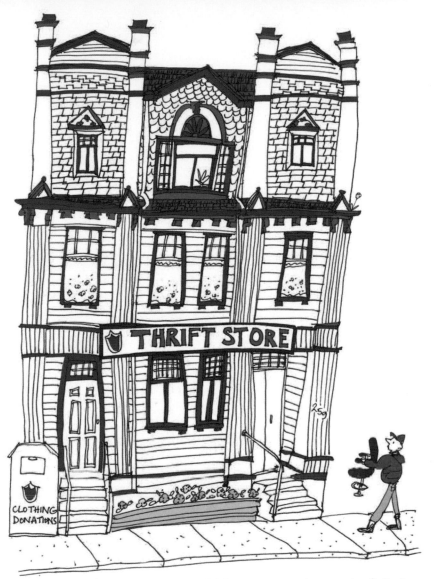

"Hey, can I take a peek? Oh — you are drawing the Sally Ann, it is going to move down the street there soon . . . What's going to happen to this building? Oh I hate to think about it, I think they might tear it down."

I wonder about this 'they' that always seems to come along and take down what is beautiful.

SUMMER

Summer is a force that feels like it can last forever at its height. Towns and countryside both buzz with activity all down the shore. It is a question of making wise choices, as you can't be everywhere at once. What is a given is that a beach is never far.

The scent of freshly made waffle cones waft from Dee Dee's open window; people line up for ice cream before visiting the lighthouse at Peggy's Cove in the summer. Thousands of tourists visit the site each year.

I ask a friend who lives nearby if he ever goes to the Sou'Wester restaurant, overlooking the lighthouse, for family dinners. He says yes, but only when there are winter storms and the power goes out. Locals pile into the restaurant, powered by a generator, and eat all together, finding warmth and light.

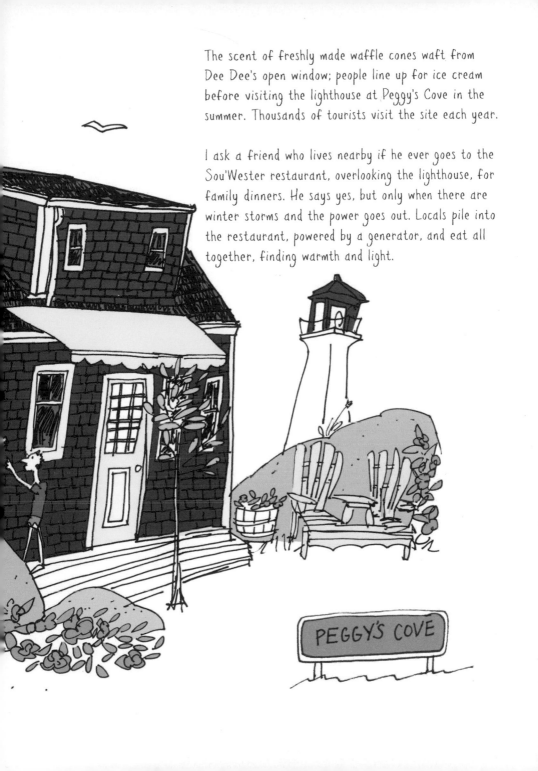

PEGGY'S COVE

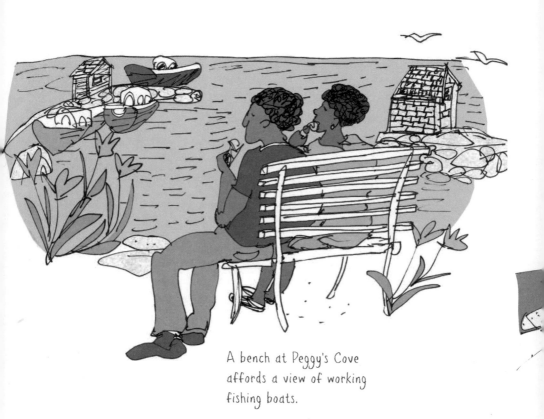

A bench at Peggy's Cove
affords a view of working
fishing boats.

A wooded trail leads to a look-out point and guaranteed peace and quiet at Polly Cove, or so I thought as I walked along the trail. But a singing voice reaches me through the trees. It sounds warm and full; it must be amplified. I turn a corner and come to a clearing. There, singing into a microphone, is Nigel Chapman — lead singer of Nap Eyes, a Halifax indie band — performing for a handful of friends.

As I sit down on the rocks, other Halifax musicians play in turn, including Jess Lewis of Cactus Flowers. The music only adds to the sweetness of the landscape, shaped by glaciers long before any humans touched it.

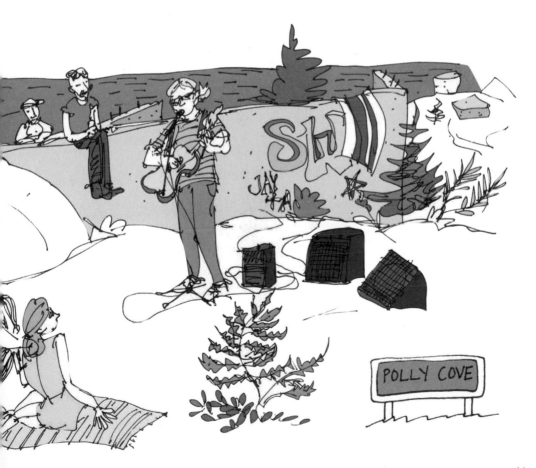

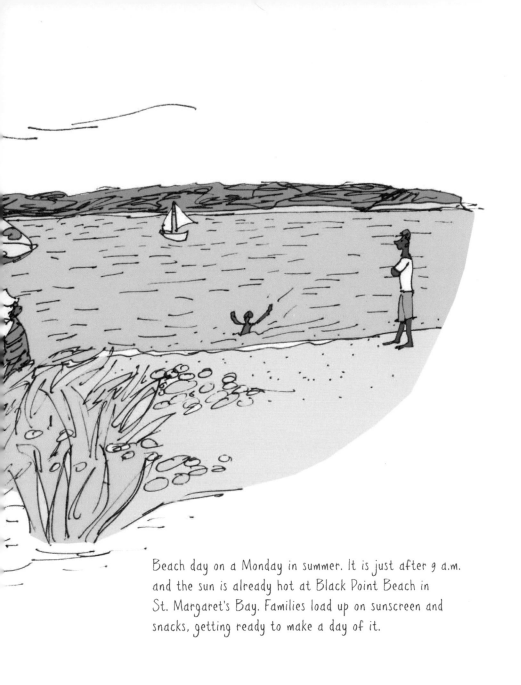

Beach day on a Monday in summer. It is just after 9 a.m. and the sun is already hot at Black Point Beach in St. Margaret's Bay. Families load up on sunscreen and snacks, getting ready to make a day of it.

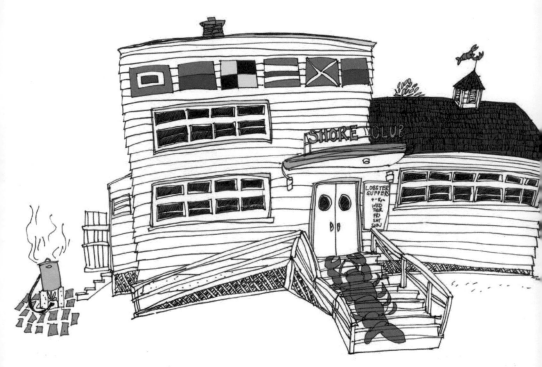

There are lobsters on the boil at the Shore Club in Hubbards, a South Shore tradition since 1946. Much of the building material for the restaurant/concert venue, including the floors and windows, came from a military base that was dismantled in Debert, Nova Scotia, when WWII ended. Those floorboards have been danced on now for decades on Saturday nights through the summer, after lobster dinners with all the fixings.

HUBBARDS

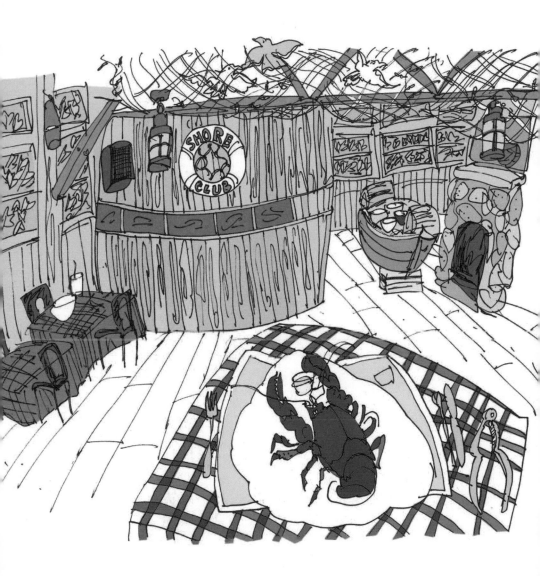

BLANDFORD

An old fisherman's cottage in Blandford is now occupied by installation artist Lisa Cochrane, who finds inspiration in found objects. On entering the house, visitors are greeted by a large whale pelvis, found on the beach. Scrubbed up and on display, it is a sculpture in its own right. Around back, sumac trees and a Japanese maple dance in the breeze.

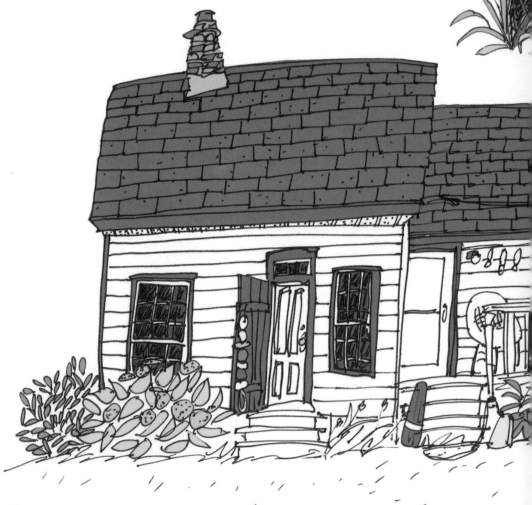

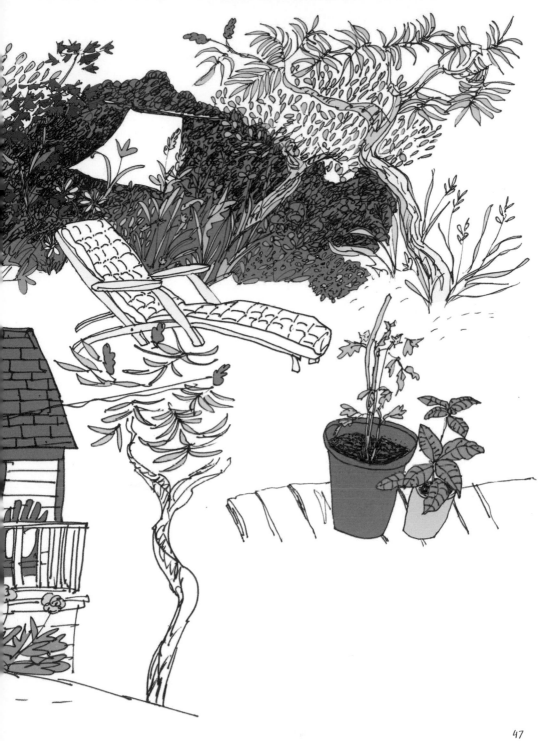

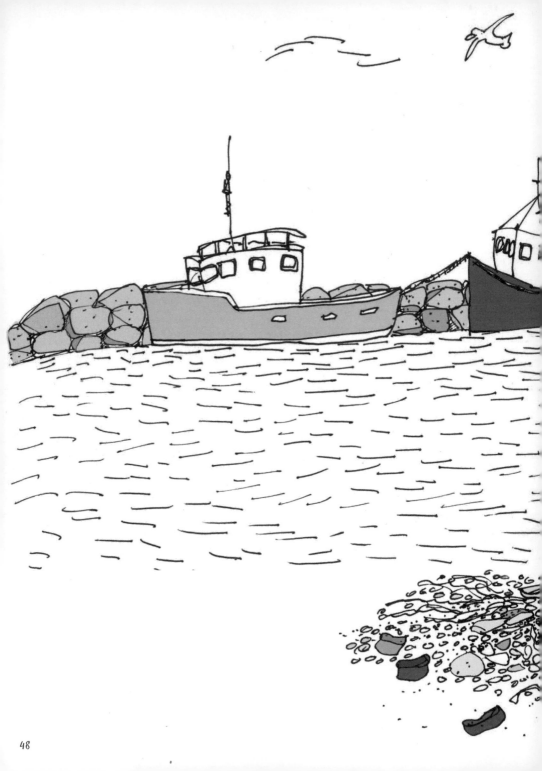

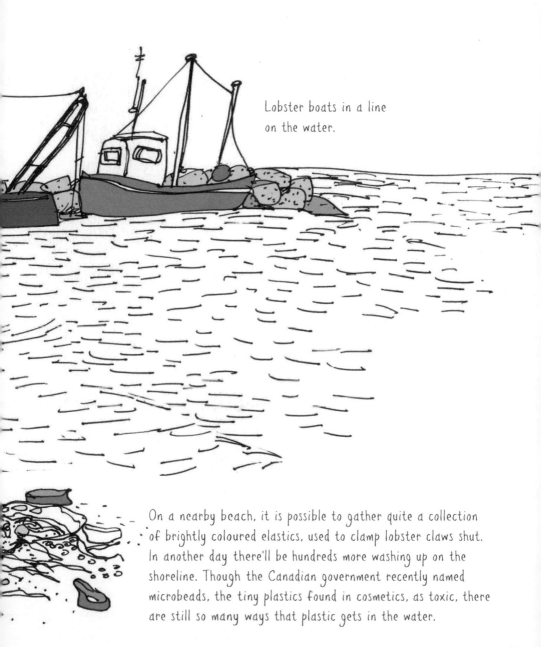

Lobster boats in a line
on the water.

On a nearby beach, it is possible to gather quite a collection
of brightly coloured elastics, used to clamp lobster claws shut.
In another day there'll be hundreds more washing up on the
shoreline. Though the Canadian government recently named
microbeads, the tiny plastics found in cosmetics, as toxic, there
are still so many ways that plastic gets in the water.

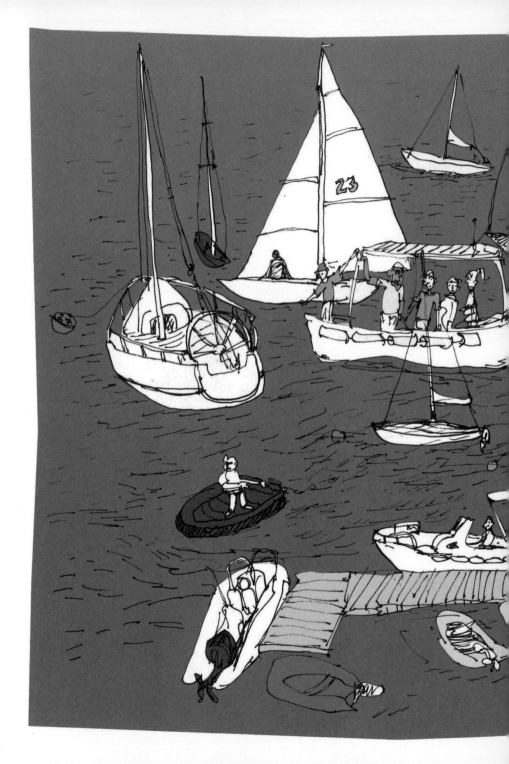

Overheard during Chester Race Week:

"My father told me about one time he drove from Kentville to Chester. He sure was hot, and first thing he did was sit on the dock when he got here. Didn't someone just jump right over his head and into the water while he sat there? I wonder if it is that dock right there where it happened?"

And someone else:

"Oh yeah, I am not living here anymore. We've got a place in Whistler now — good for skiing, but I come back for the sailing in the summer."

CHESTER

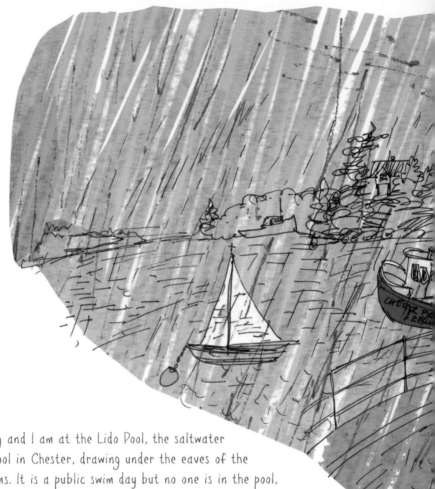

It is raining and I am at the Lido Pool, the saltwater swimming pool in Chester, drawing under the eaves of the change rooms. It is a public swim day but no one is in the pool, and the two lifeguards are on Facebook inside. A man in a wet suit approaches.

"Coming in for a swim?"

"Nope, going out for a kayak."

And he slips into his boat, paddling into the Back Harbour. With all the water around, it is hard to believe that wells are dry and the South Shore is experiencing a drought.

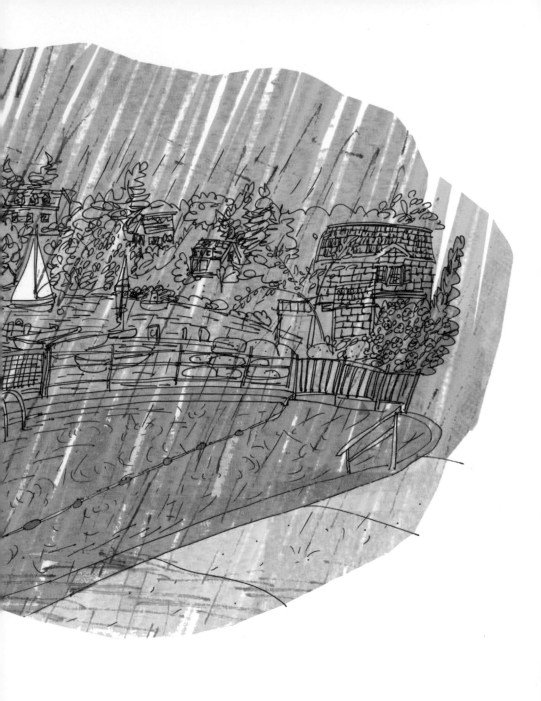

On a hot day, I am looking for a fridge with a friend, so we head to Calvin's.

"I always like to support the family businesses," she says.

"Is Calvin a real person?" I ask.

Sure enough, we are greeted by Calvin. Stepping into his shop, you feel the cool relief of air conditioning, as though entering a walk-in fridge.

RCA

WASHERS
FRIDGES
STOVES
FREEZERS
DISHWASHER

MON 8-3:30
TUES
WED
THURS
FRI
SAT
SUN CLOSED

OPEN

Calvin's
TV

AUTHORIZED DEALER OF
·MAYTAG·
·KITCHENAID·
FRIGIDAIRE·
·WHIRLPOOL·
·GE·PANASONIC

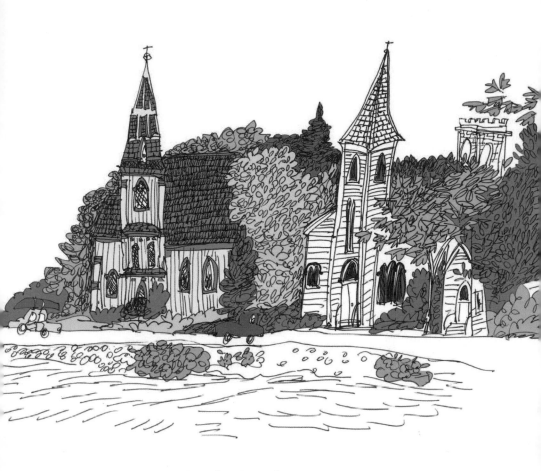

The three churches in Mahone Bay, St. James Anglican Church, St. John's Lutheran Church and Trinity United Church, create a postcard-worthy welcome to the town. Trinity United was built in a different location with a different name in 1861, but was moved to the water's edge by a team of oxen in 1885.

MA HONE
BAY

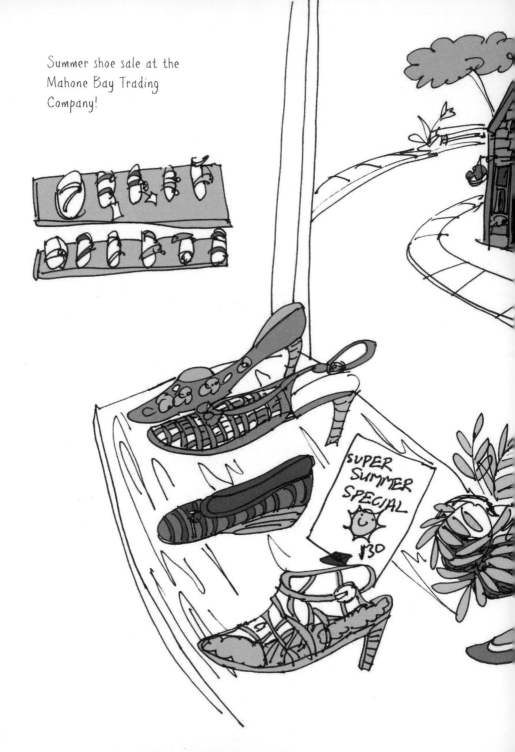

Summer shoe sale at the Mahone Bay Trading Company!

SUPER SUMMER SPECIAL
$30

A meeting of two very different local industries: an ABCO Plastics mug is a vessel for a bouquet from the Littlest Flower Farm, sold at the Lunenburg Farmers' Market. The flower farm is a one-woman show, run by a florist who harvests flowers in fields and even ditches. ABCO Plastics started in Lunenburg in 1956 and moved to Mahone Bay in 1965. The company makes fibreglass reinforced plastic. It has expanded over the years to large-scale mining and chemical applications around the world, including in England, the Czech Republic, Thailand and Taiwan.

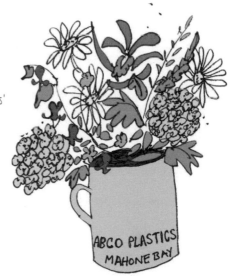

Michele Stevens is a fourth generation
sailmaker, following a tradition that began
for her family on Big Tancook Island.
She now runs Michele Stevens Sailloft on
Second Peninsula, employing three people.
They sit tucked into holes cut into the
floor, allowing the sails to spread out and
fill the room while the sewing machines sit
on the wooden floorboards.

At the sail loft the radio station alternates between old time rock and roll and the gardening call-in show on the CBC, in an effort to appeal to everyone's tastes.
When the work day is over, I get a ride back to Lunenburg with a woman who has worked at the shop for over a year. We wait awhile for her husband to pick us up; he is observing Ramadan and is coming from prayers at the mosque in Blockhouse. When he arrives, the back of the car is full of food to be consumed after sunset, in accordance with the month-long fast during daylight hours. In mid-June, that won't be until after 9 p.m.

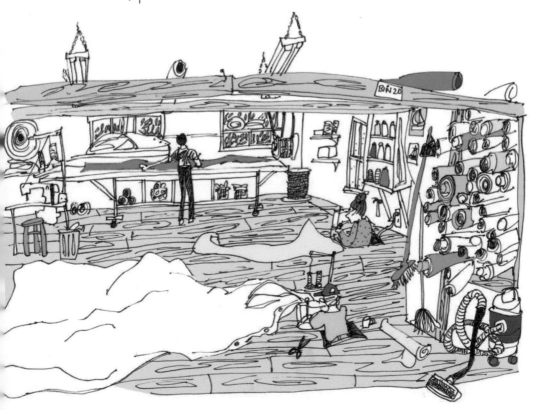

In early summer, the sides of the roads thrum with things growing. I put my hand in my pockets and find wild roses, clover blossoms and spruce tips I picked while walking on Second Peninsula earlier, their fragrances still strong. To prolong the enjoyment of these plants, you can make them into a tea, or infuse them in honey or vinegar.

For rose vinegar, follow the poetic incantations of George Elliott Clarke, Canada's poet laureate, hailing from Windsor, Nova Scotia.

ROSE VINEGAR

In his indefatigable delirium of love, Xavier wires rugosa rose blossoms to Shelley. Deluded by his quixotic romanticism, he cannot yet appreciate the practical necessities of friendship. But, Shelley trusts in reason; thus, though she admires the blossoms for their truthfulness to themselves, she does not hesitate to distill a delicate and immortal vinegar from what she considers the ephemeral petals of X's desire. An ornament becomes an investment. She fills a cup with the fresh rose petals; then, stripping off their heels (the white part), she pours the petals into a quart sealer and adds two cups of white vinegar. Then, she seals the jar and places it on the sunny living room windowsill for sixteen days, seven hours, and nine minutes. When the vinegar is ready, she strains it through a sieve and then pours it back into the bottle.

Rose vinegar. It's especially good on salads.

— George Elliott Clarke, *Whylah Falls* (Gaspereau Press)

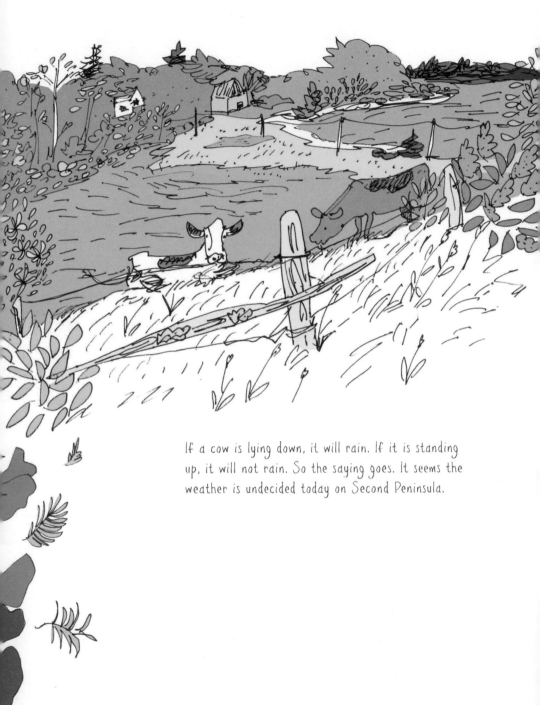

If a cow is lying down, it will rain. If it is standing up, it will not rain. So the saying goes. It seems the weather is undecided today on Second Peninsula.

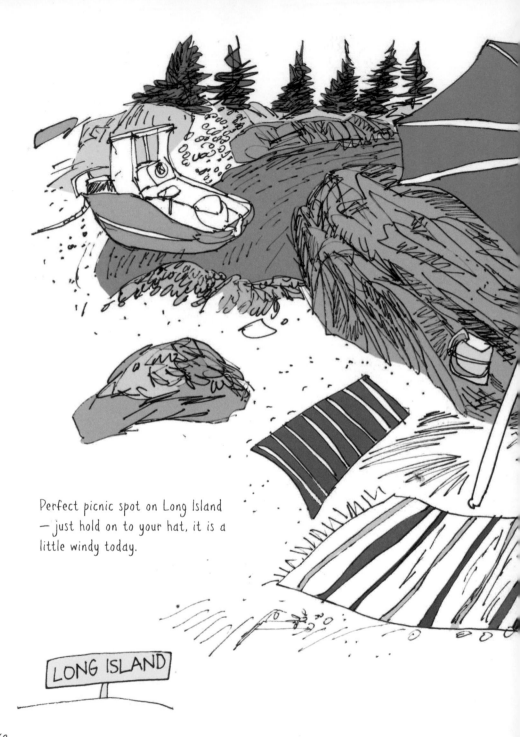

Perfect picnic spot on Long Island
— just hold on to your hat, it is a
little windy today.

LONG ISLAND

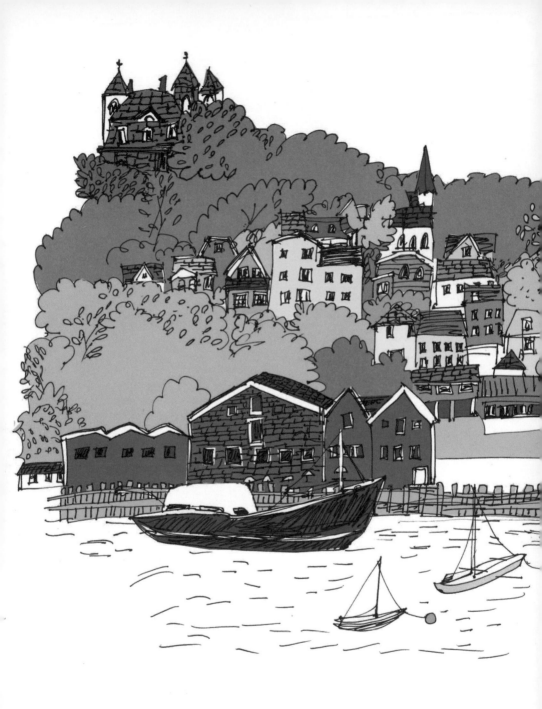

The red-roofed Academy building sits atop Lunenburg, the town unfolding below it like a many-coloured quilt. It opened in 1895 as the local elementary school, and closed its doors in 2012. It is now happily being repurposed as the Lunenburg Academy of Music and Performance, and a municipal library and office space.

Singer Joel Plaskett's song "Beyond, Beyond, Beyond" begins with a reverie of days spent going to school there:

Me and you on Gallows Hill
1980, 1 or 2
Hurry up and tie your shoe
We're gonna be late for school
Passing through the gravestones as we're drawing near
I do not know anyone who's buried here

In the basement singing songs
Hughie, turn the PA on
Judy let us rock that room
Out of time and out of tune
Walk the streets of Lunenburg, recall the time
I'm counting all the crows upon the power line . . .

LUNENBURG

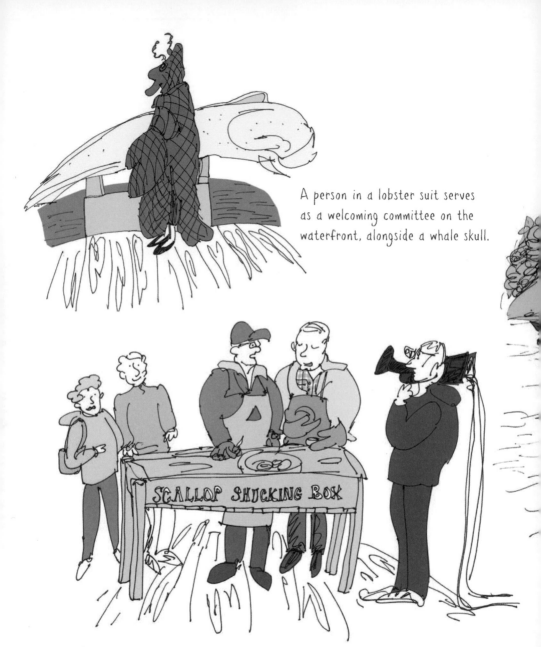

A person in a lobster suit serves as a welcoming committee on the waterfront, alongside a whale skull.

Jeff Hutcheson was the host of the popular breakfast TV show *Canada AM* for eighteen years. His final show out of the studio was a trip to Lunenburg, where he learned how to shuck scallops with Captain George Pike, who spent thirty years on the water.

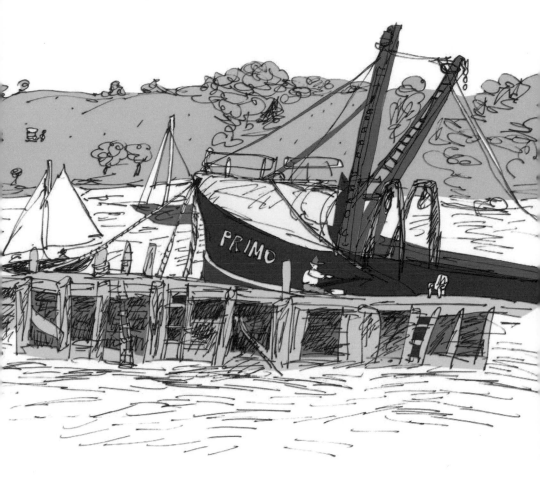

It is not just houses that need to get repainted in Lunenburg. The *Primo* gets a paint job on the waterfront.

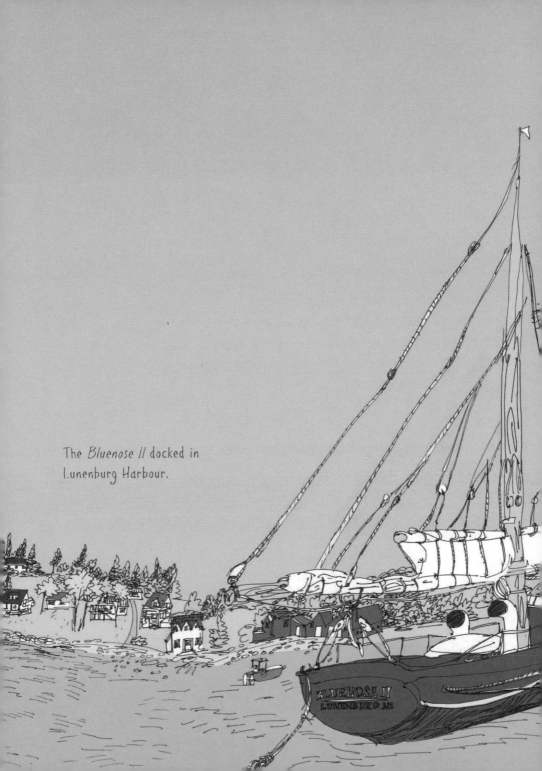

The *Bluenose II* docked in Lunenburg Harbour.

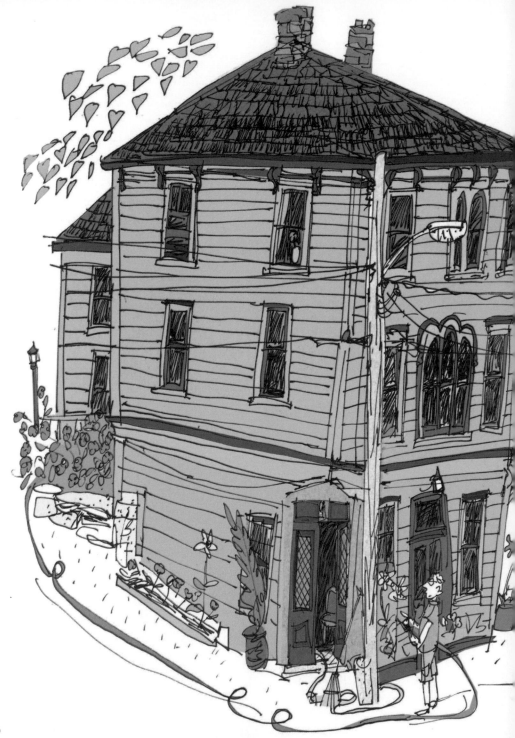

Doug Bamford lives on the corner of Prince and Pelham Streets in Lunenburg, earning him the title "Prince of Pelham," which he lives up to as he waters his fig trees and sunflowers on a hot July day. He holds other titles, including program director for the Lunenburg School of the Arts, and ceramic technician at NSCAD University, the art college in Halifax. He calls his abode the Fairbanks in reference to another Doug — Douglas Fairbanks, an early Hollywood actor from the 1920s. The house also lives up to its title, playing host to artists and opera singers, writers and dreamers, always with a table laden with food and wine.

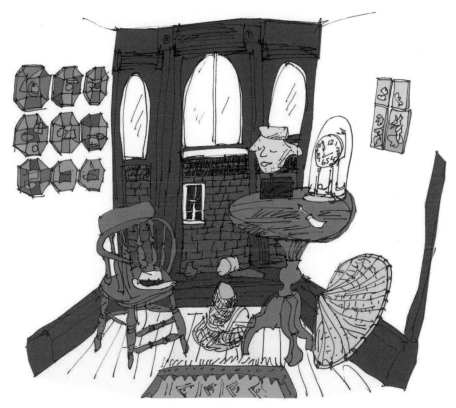

Inside, ceramics cover the walls, and objects have stories to tell.

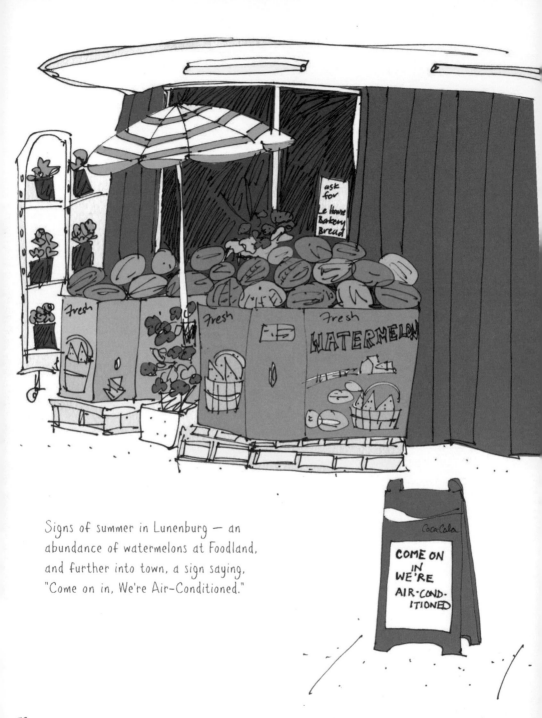

Signs of summer in Lunenburg — an abundance of watermelons at Foodland, and further into town, a sign saying, "Come on in, We're Air-Conditioned."

Lincoln Street Food, on Lincoln Street in Lunenburg, marries local food with fine dining. To start, you could have a market mayhem salad, which brings you the best that the Lunenburg Farmers' Market has to offer. After, you could try pan-seared halibut with knotweed pesto. This twist on pesto, typically made with basil, makes the most of an invasive plant species that threatens the coastal landscape and many backyards, but is in fact edible.

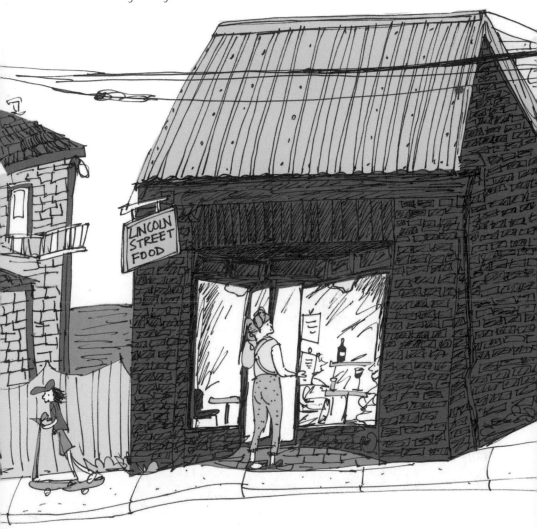

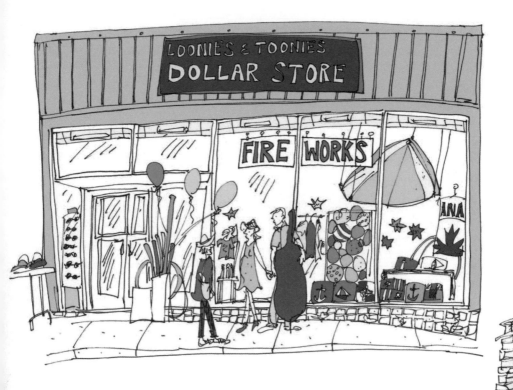

With the Loonies & Toonies Dollar store as a backdrop,
Lunenburg Folk Harbour Festival-goers and performers
catch up on summer news.

I wonder how many loonies (or toonies) it would take to
buy a tent. A popular summer camping spot on the shore
is Kejimkujik Park, but you need to book in advance.

3, 2, 1, action! A film crew turns the corner at King Street in Lunenburg, and soon disappears down the colourful streetscape with piles of orange pylons and power cords left in its wake.

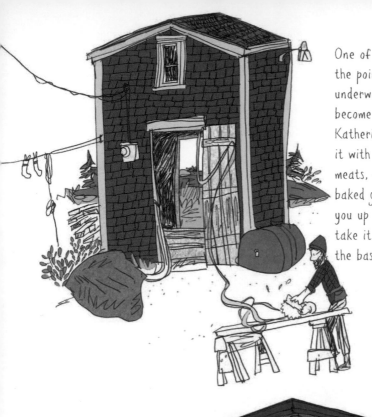

One of the fish shacks at the point on Blue Rocks Road underwent some renovations. It has become the Point General, run by Katherine Marsters. She has filled it with local art, ice cream, cured meats, freshly brewed coffee and baked goods for sale. She'll pack you up a picnic if you'd like to take it on a kayak trip, but return the basket when you are done!

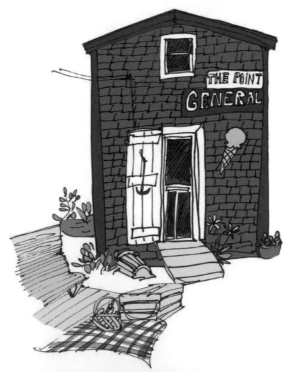

Katherine's brother Karl Marsters worked an office job in Halifax for many years, but always dreamed of working on the water. His dream came true in 2009 when he opened Pleasant Paddling. He guides kayak trips through Blue Rocks, providing rentals as well. His tours take people between islands once connected by footbridges when they were home to active fishing communities. Some working fish shacks remain along the Point Road, where his tours launch into the water.

Both his and Katherine's work, like so many people's on the South Shore, is seasonal, tapering off in the fall. Thanks to the ebb and flow of his business, when his wife's maternity leave ended and she returned to her job as an architect he was able to parent from home for the winter.

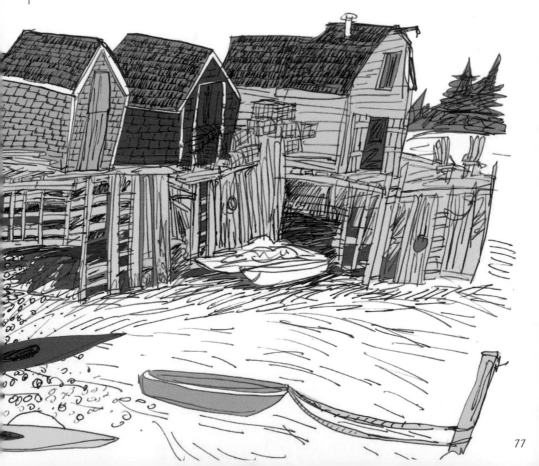

This iron bridge in Bridgewater was constructed in 1891 and is still in use, referred to as the 'old bridge.' On a muggy summer night, the moon rises over the river.

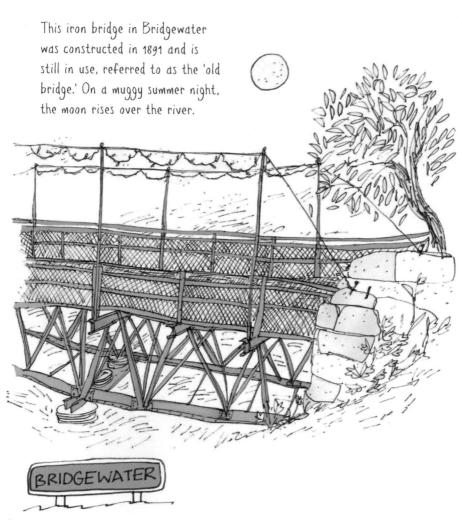

BRIDGEWATER

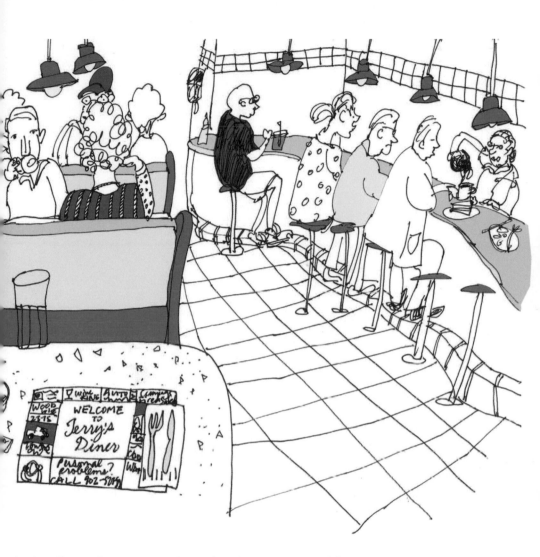

I sit in Jerry's Diner, contemplating breakfast options and listening to the cross-country weather report. It is twenty-two degrees in Vancouver. In Bridgewater it is ten degrees, and locals are bracing for Tropical Storm Colin.

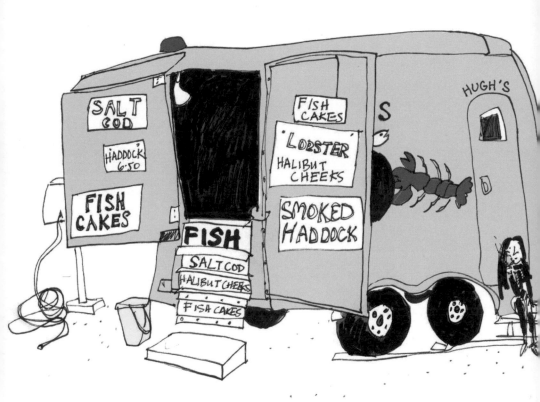

I happen upon a smoking goth and smoked haddock
cheeks at Hugh's Fish Truck in Bridgewater. Hugh spent
twenty-five years on the water as a fisherman in
Woods Harbour.

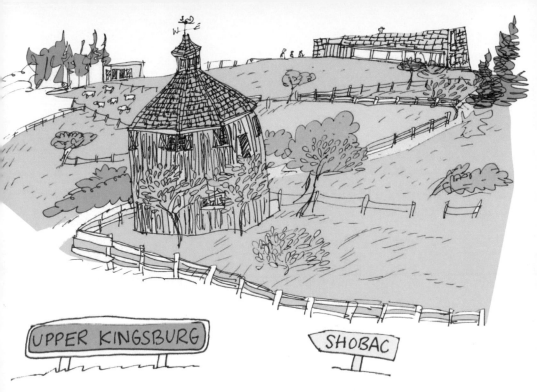

UPPER KINGSBURG SHOBAC

Shobac, a piece of land in Upper Kingsburg, acts as a laboratory for Nova Scotian architect Brian MacKay-Lyons of MacKay-Lyons Sweetapple Architects. His Ghost Labs have partnered with architects and architecture students from around the world, realising design build projects for twelve successive summers — including a 're-raising' of the Troop Barn, an octagonal barn built in 1888 and slated for demolition until it was moved and reassembled at Shobac.

I attended the final Ghost Lab, a conference instead of a design build, with the theme Ideas in Things. At the event's closing party I met Juhani Palasmaa, Finnish architect and phenomenologist, who has said that the door handle is the handshake of a building. Our meeting, on the threshold of the open barn door with a full moon overhead, sheep in the fields and the music of Garret Mason's Blues Band playing, seems proof to me that it is people who make buildings successful, but good buildings help make it easy for people to enjoy themselves.

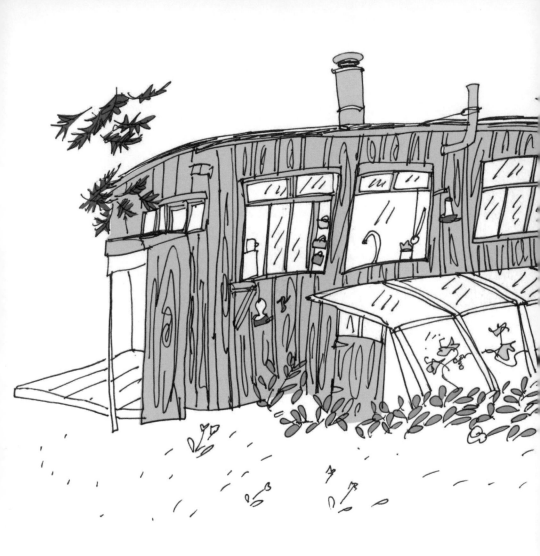

EAST BERLIN

The haskap berries are finished for the season on this homestead in East Berlin, but the blueberries are just coming in. Betsy Hart and Robert Iuliucci operate Bear Cove Resources from the home they built. True to the back-to-the-land movement, they live off the land and sea. They harvest seaweed, which they compost and sell as fertilizer. To do their work they have three licenses from the government of Nova Scotia. The 'Permit to Remove Material from Beaches' and 'Vehicle Beach Permit,' from the Department of Natural Resources, regulate the location, time and quantity of seaweed to be removed and the type of vehicle used. The 'Permit to Operate a Compost Facility,' from the Department of Environment, sets guidelines for the operation of a commercial compost facility.

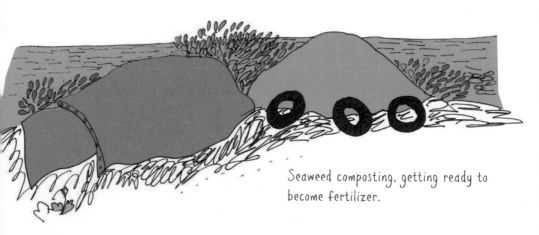

Seaweed composting, getting ready to become fertilizer.

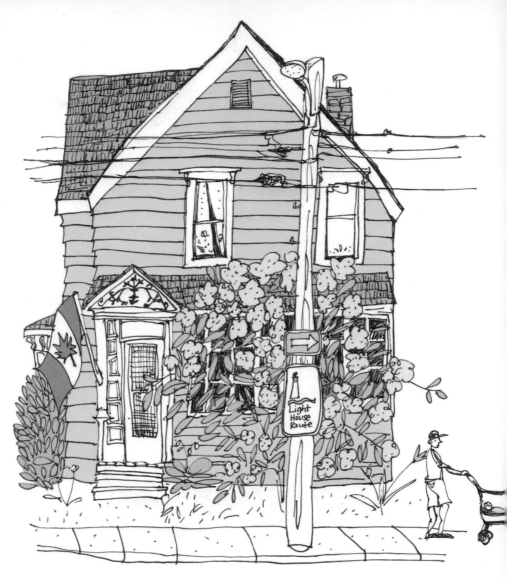

This house in Liverpool is on the Lighthouse Route, a 339-kilometre stretch of road that links forty-six lighthouses between Halifax and Yarmouth, according to the Lighthouse Preservation Society's website. There are more than 150 lighthouses in the province. The closest lighthouse to Liverpool is Fort Point Lighthouse.

LIVERPOOL

I am sketching Liverpool town hall from the front. "Oh, what you got there? Are you drawing that weather vane on the top of the building? I'd say you're one of the only people who's even noticed it since they put it up there."

"Oh, but you know what happened last week? They screened the Tragically Hip's last concert in the Astor Theatre there. The theatre was full right up, it was awesome."

A youth who looks like they might be in theatre camp at the Astor, the impressive soft-seated theatre housed in the town hall, flies by on a scooter, wearing a hat not unlike the ones worn by the Hip's front man, Gord Downie.

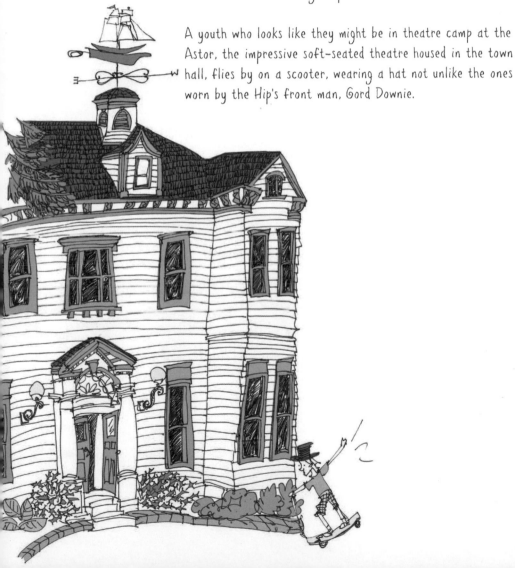

FALL

Fall is at first a slow mellowing of summer, and often there are still warm days into October. There is a sense of 'back to school' no matter your age, and people begin hunkering down into craft and woodworking projects that were neglected during the busy summer months.

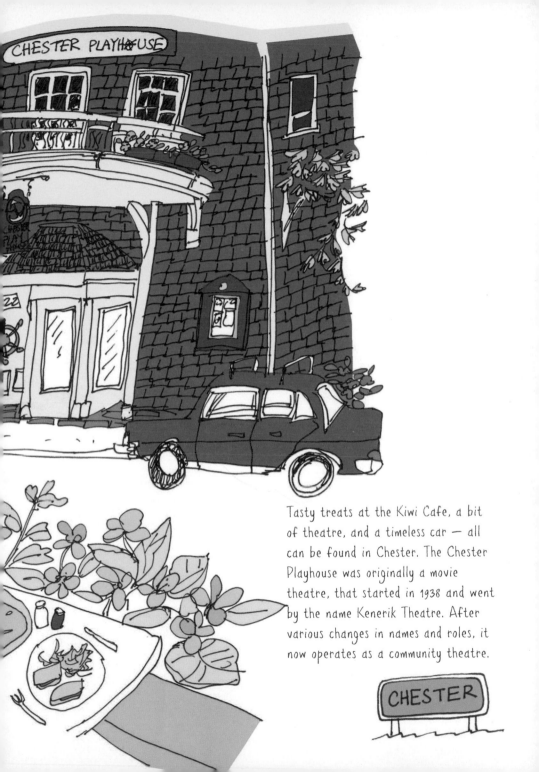

Tasty treats at the Kiwi Cafe, a bit of theatre, and a timeless car — all can be found in Chester. The Chester Playhouse was originally a movie theatre, that started in 1938 and went by the name Kenerik Theatre. After various changes in names and roles, it now operates as a community theatre.

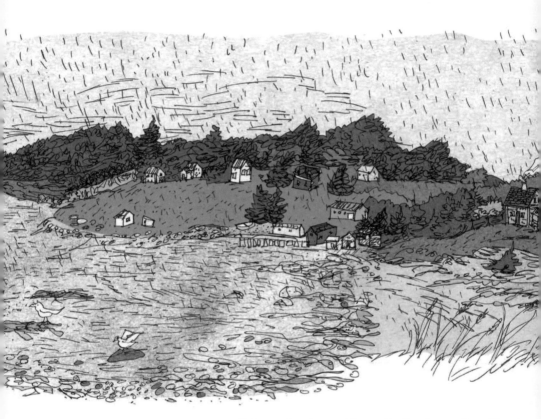

It is a rainy day on Tancook's Southeast Cove Beach. A mother says to her two sons, "I have an idea, why don't you race each other to the end of the beach?" Neither is too impressed, and they settle for looking for sea glass instead.

BIG TANCOOK ISLAND

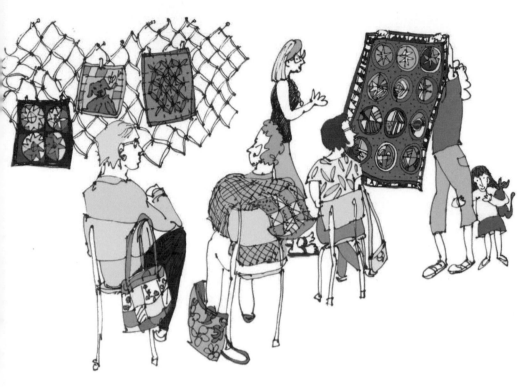

The Mahone Bay quilt guild meets monthly in the hall of the Trinity Church. There are 115 members, plus eight lifetime members. The chair of the meeting encourages any members over eighty to come forward to become lifetime members and enjoy the benefit of forgoing yearly fees.

"Any members aware of anyone turning eighty who doesn't want to tell? It is getting harder and harder to know what age you all are, so you are going to have to get a friend to squeal on you or admit it yourself!"

When the 'sew and tell' happens, the youngest in the room goes to the front with her grandma and her purple cat, a pillow based on a drawing she did.

MAHONE
BAY

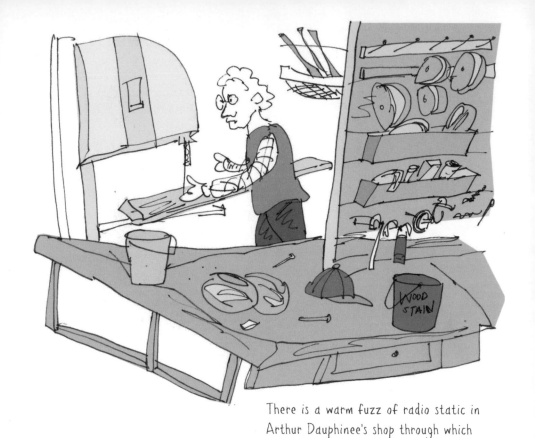

There is a warm fuzz of radio static in Arthur Dauphinee's shop through which classical music can be heard. Arthur makes wooden blocks for tall ships around the world — his handiwork can be found on boats as far away as Asia. His website declares, "Quality products for 150 years. Manufacturer of wooden commercial tackle blocks, wooden yacht blocks, Lignum Vitae deadeyes, parrels, ash blaying pins, tinned & not tinned fish gaffs, bailers, wooden ice mallets, hook sets, brass and (hand) trawl fids, maple fids, lignum vitae trawl rollers & miscellaneous wood hardware tholepins, bullseyes, mis. galvanized hardware." He took over the business from his father, who taught him the trade.

SECOND PENINSULA

On the wall, Arthur has kept an almanac of sorts, recording the weather with felt pen on the drywall. There is no particular method to his note taking, with dates flying at random, but much is revealed even in this sampling:

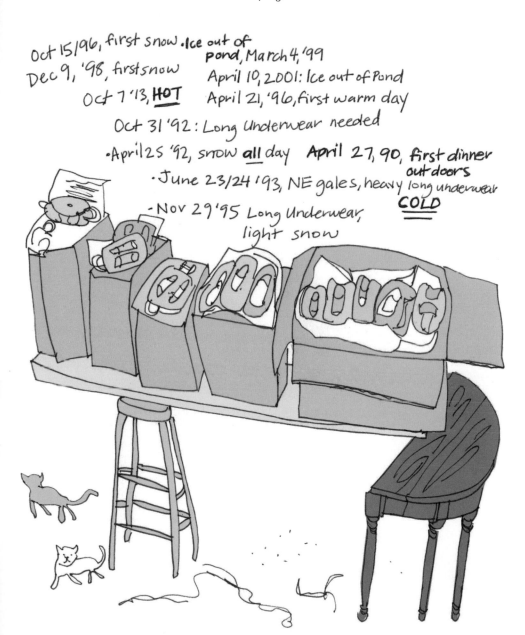

Oct 15/96, first snow. Ice out of
pond, March 4, '99
Dec 9, '98, first snow
April 10, 2001: Ice out of Pond
Oct 7 '13, **HOT**
April 21, '96, first warm day
Oct 31 '92: Long Underwear needed
•April 25 '92, snow **all** day April 27, 90, first dinner
outdoors
•June 23/24 '93, NE gales, heavy long underwear
COLD
-Nov 29 '95 Long Underwear,
light snow

LUNENBURG

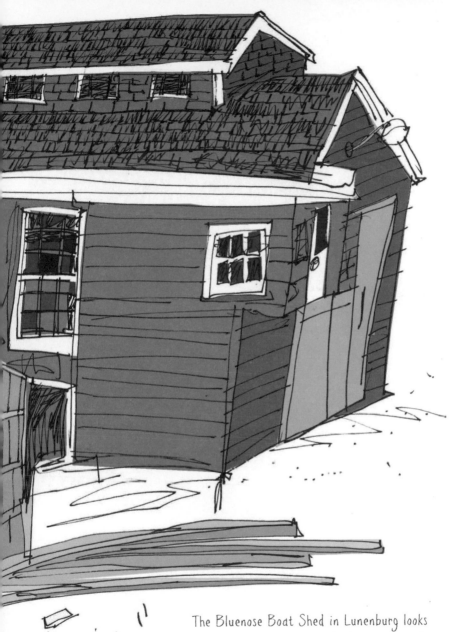

The Bluenose Boat Shed in Lunenburg looks
rectilinear from the outside, but once inside its
arched structure makes it feel more like the inside
of a chapel, or the belly of a whale.

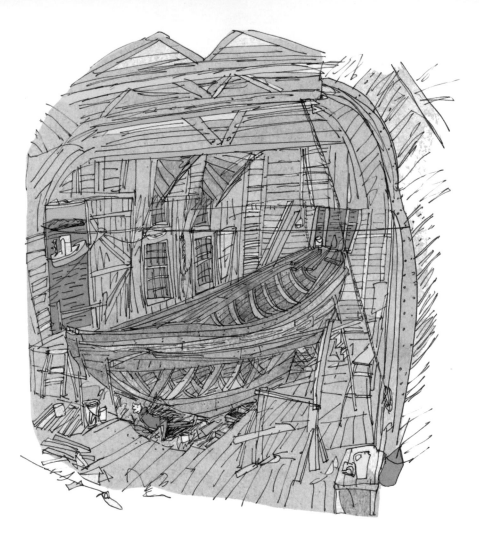

Inside, the Blue Dream project is underway — an international project that aims to educate people about the dangers of plastic in the ocean. A sixty-foot boat is being made in the traditional manner used in Lunenburg when the town supplied fleets of fishing boats. Once it is seaworthy, the boat will act as an ambassador for the project — hosting scientists, youth and artists as it travels around the world on a quest to protect our oceans. The boat's name, *Mayahana*, is Buddhist in origin and means 'Great Vehicle' in Sanskrit.

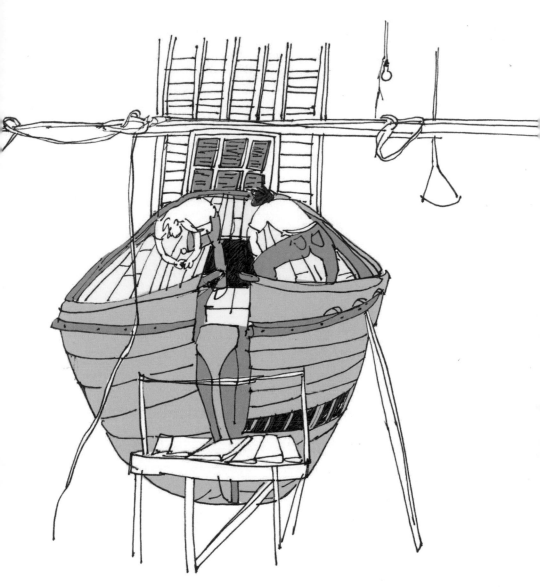

Though some power tools were used in the making
of the boat, much of the work was done by hand,
reviving techniques that have been passed down orally
and only by example, not via YouTube.

The shopkeeper at Front Harbour Marine Supplies says to Tim the delivery guy, "Geeze, you must be busy getting here at this hour."

He answers, "No, geeze, I'm late. Broke my ribs Friday. They didn't get anyone to do my orders for me. And then it's like people's brains turn off when you get to Lunenburg, impossible to get anywhere."

After Tim leaves the shopkeeper says to a customer, "That guy, he starts his day in Dartmouth, finishes the day in Yarmouth or Liverpool at least."

The Lunenburg Royal Canadian Legion is Branch #23, formed in 1926. Bartender Rebecca Huskins grew up in another Lunenburg historic landmark — the nearby Battery Point Lighthouse keeper's home. Her parents manned the lighthouse until it became automated in 1989. "I was there from the time I was born until I was twenty-four."

When I ask what kind of beer she has on tap, Rebecca meets me with a question: "Well first of all, are you a member?" "No." "Well you gotta be signed in by a member then." The woman ahead of me signs me in. "Okay, we'll need to see some ID now . . ." The next person in line is also greeted with a question: "And so do I even need to be told what you're having?"

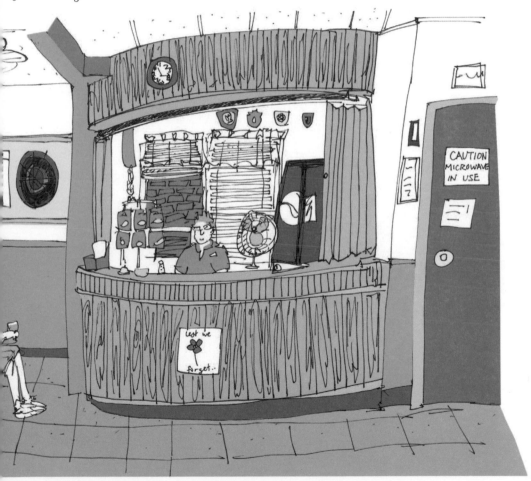

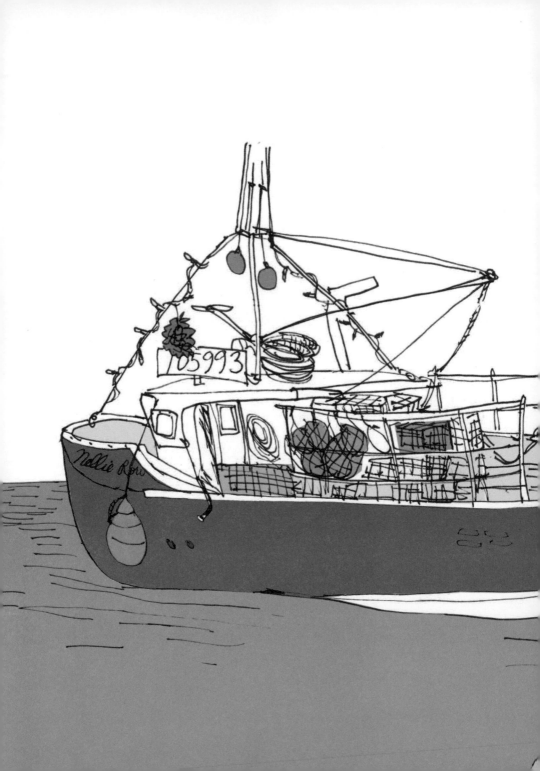

"Nice boat there, who does it belong to?"

She says, "It's mine. I'll be out fishing on it for the season."

The response: "Oh, good to know women are getting out of the kitchen these days."

I pause in my drawing, and think of all the women running businesses in the town of Lunenburg and all up and down the shore. I hope there comes a day when such comments don't exist.

Meanwhile, the fisherwoman is back to her work, and so I resume mine.

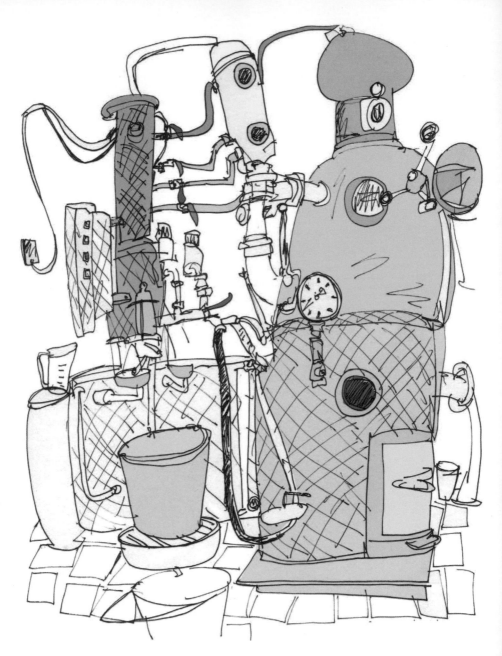

The still at Ironworks Distillery is a copper contraption from Germany, and looks like the stuff of a mad scientist's dreams.

Housed in Lunenburg's former blacksmith shop, the distillery still holds some clues to its past, including an old bellows hanging from the ceiling. The Pear Eau de Vie liquor is a feat of engineering, with the bottles attached to pear trees in blossom on the Boates Farm in Woodville, allowing the pear to grow inside the bottle.

The distillery keeps up with literary goings on in the province, and created this drink inspired by Nova Scotian poet Sue Goyette's masterwork, *Ocean*, published by Gaspereau Press in 2013:

- 1 oz Ironworks Bluenose Dark Rum
- 1 oz Ironworks Cranberry Liqueur
- 1.5 oz Ginger Beer
- Dash freshly squeezed orange

PREPARATION:
In a rocks glass add rum, liqueur and ginger beer over ice. Stir and add a squeeze of orange, rimming the glass with orange rind to finish.

. . . Imagine, the ocean basting us. But how often had we walked into its salted air then licked our arms/ to taste it later? We were being seasoned. Lightly. Of course we rebelled,/ refusing to be in its roasting pan.

— Sue Goyette, *Ocean*, "Poem Seven"

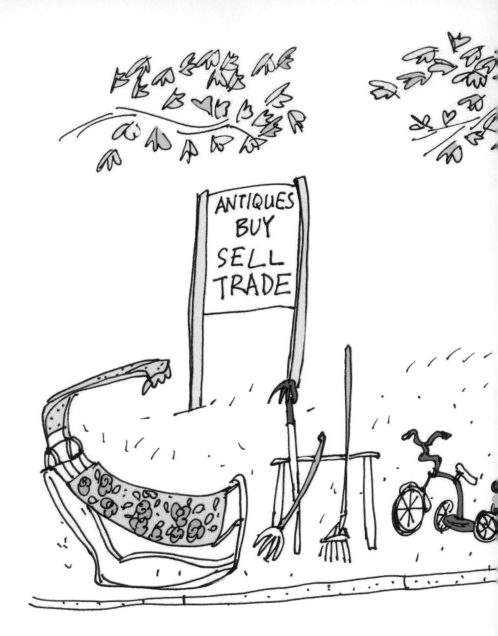

Roadside attraction in Bridgewater.

RIVERPORT

Gypsophilia, a popular band from Halifax, has made a tradition of playing packed Halloween shows at the Old Confidence Lodge, complete with an audience in full costume. The lodge is an old theatre/dance hall built by the Oddfellows in 1929. It has been lovingly turned into a recording studio and concert venue by Diego Medina, who immigrated to Canada from Chile. He brings his skills as an audio engineer and producer to the vibrant music scene on the South Shore.

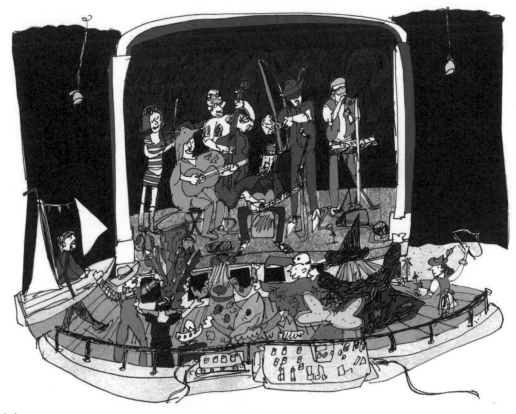

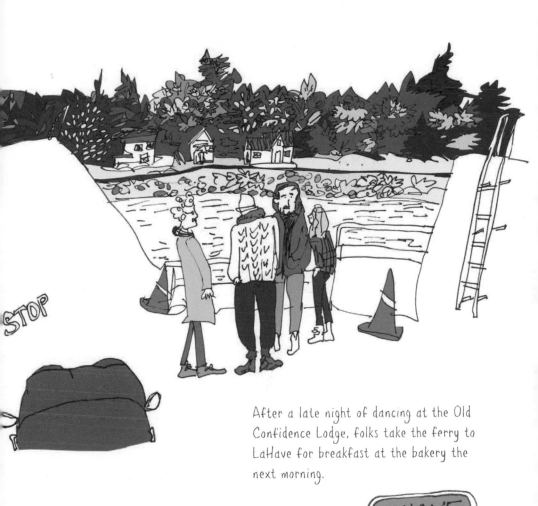

STOP

After a late night of dancing at the Old Confidence Lodge, folks take the ferry to LaHave for breakfast at the bakery the next morning.

LAHAVE

The LaHave Bakery's yellow awning and welcoming chairs are a perfect place for breakfast even on a rainy day.

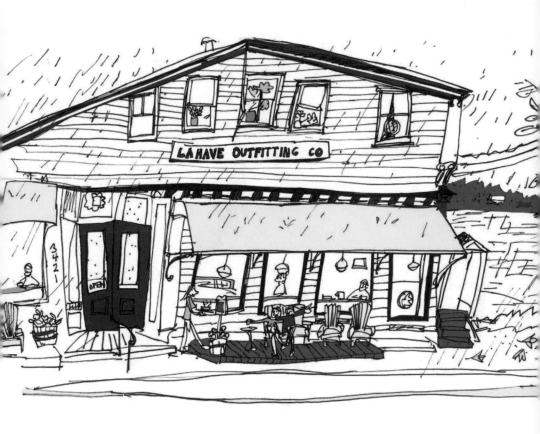

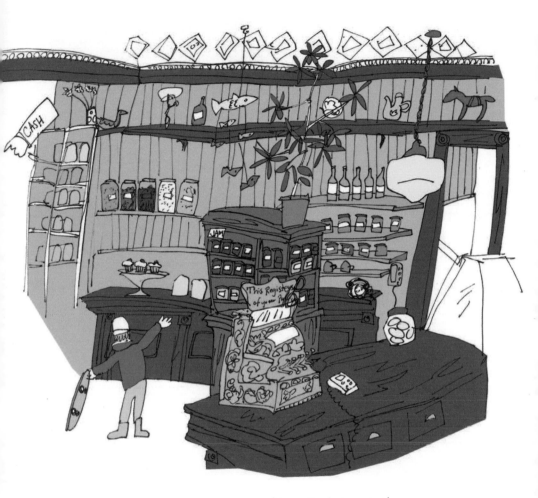

Above the bakery is Homegrown
Skateboards, a skateboard shop complete
with an indoor skate bowl. A young skate
shop patron comes down to the bakery
for a treat, perhaps going back upstairs
to skateboard after.

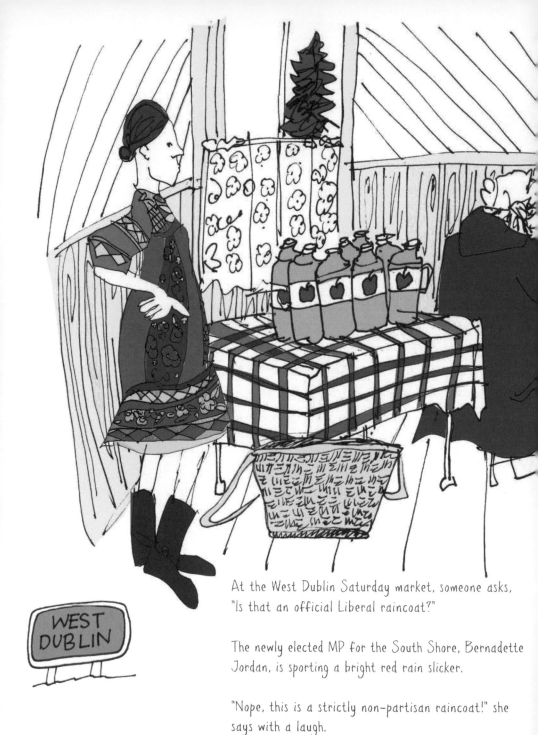

At the West Dublin Saturday market, someone asks, "Is that an official Liberal raincoat?"

The newly elected MP for the South Shore, Bernadette Jordan, is sporting a bright red rain slicker.

"Nope, this is a strictly non-partisan raincoat!" she says with a laugh.

Someone else:

"I just bought my first insulated onesie."

And another:

"We've got empty houses here, we've got land. We need to let immigrants come here. We need more people, not less!"

The Sipuke'l Gallery, in the Liverpool town hall, specializes in contemporary and traditional Mi'kmaw art. I am drawn to two teacups that look almost ready for high tea, except that they are woven expertly from sweet grass and ash bark by Rose Morris, a residential school survivor.

Rose attended the Shubenacadie Indian Residential School, which operated from 1930–67, separating Mi'kmaw children from their families, language and customs. She is now a respected elder who resides in Gold River on the South Shore. There are photos of her in a binder with information about the exhibiting artists; she is pictured with the moon in the sky in 1969, by a river in 2001 and under a blossoming tree in 2004. I look at her face and wonder what memories surface for her with each season, and then look again at her handiwork.

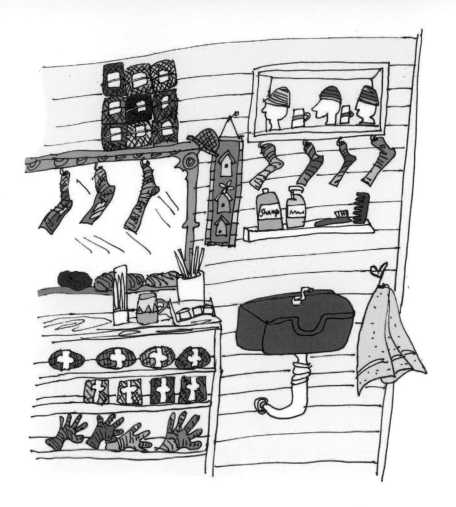

Becky of Becky's Knit and Yarn Shop in Lockeport is on the phone, talking to a client who is ordering a custom knitted pair of socks. "I'll use a yin and a yang colour, something cool and something warm. I get that from the hairdressing, thinking about colour like that. Some people don't understand that, but I know you do . . ."

The shop is a busy hub for knitters in the area, and two days a week it is a hair salon; a sink and shampoo stands ready in among the wooly socks and mitts.

Marjorie Turner Bailey is an Olympic athlete; she ran the 100 metre, 200 metre and 4 by 100 metre for Canada in 1976. She was born in Lockeport, getting her start in running at high school track meets.

"Would you train on the beach?"

"Oh yes, I'd train on that beach, in the fields. Track was something to do, we had to be in the house by 8 p.m."

She doesn't run anymore, but still wears a navy tracksuit. Marjorie is descended from Black Loyalist settlers in Birchtown, and though she spent her adult life away from Lockeport, she has returned there.

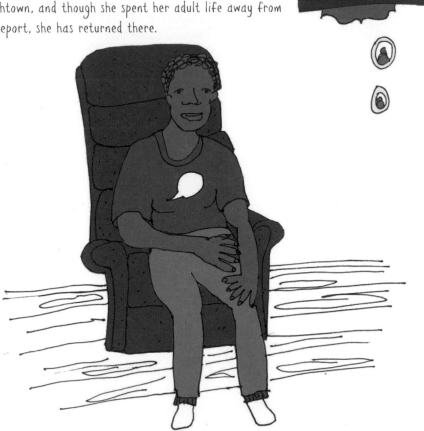

A house on Water Street in Shelburne has a front door hand-painted with flowers, reminiscent of Maud Lewis, one of Canada's most well-known folk artists. Though Maud spent most of her years painting on the Digby shore, in the 1940s she painted twenty-two shutters for an American family, the Chaplin/Wennerstroms, for their South Shore cottage in Port Mouton. She was reportedly paid seventy cents per shutter. The shutters are the biggest work she completed in her lifetime, apart from her own painted dwelling. Every surface of her humble home was covered with flowers and birds, paint swooping over shingles and up stair treads. It now resides inside the Art Gallery of Nova Scotia in Halifax.

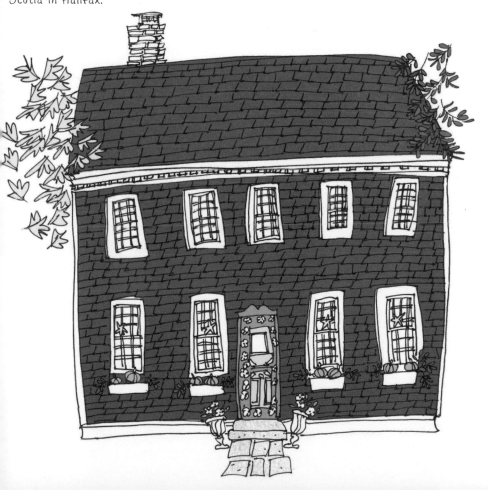

Heritage Hall houses the Shelburne Association Supporting Inclusion, which operates a laundry service out of the building. A picnic area beside the building has solar panels on the roof that heat the water. Up the street, the Capitol Theatre stands empty, waiting for someone to see potential in it.

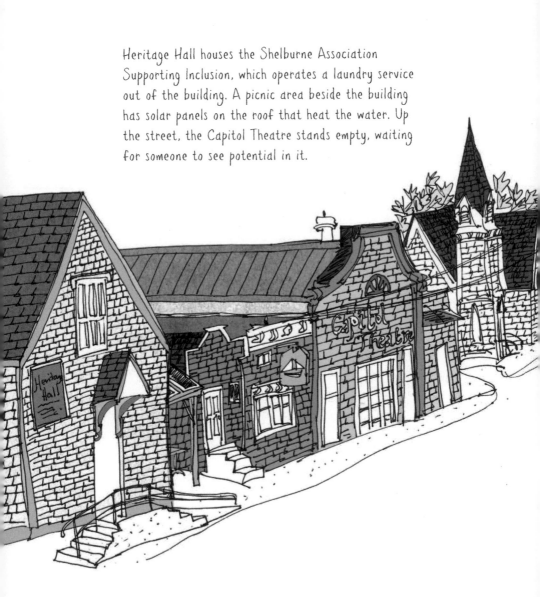

Seafood chowder and a Temptation Red beer in Shelburne at the Sea Dog Saloon is a fitting combo on a misty day. The beer is brewed up the road at the Boxing Rock Brewery, whose name comes from a rock in the harbour where bickering people of the town were sent to sort out their differences, or not, as it may be. When I visited the Black Loyalist Centre in Birchtown, a fisherman-turned-museum-worker assured me there really was a rock in the harbour with that name, and that it was quite large. "Oh, it's about the size of a car, or two." Not a place you'd want to spend too much time.

OPEN 2.25

YARMOUTH

The Murray Manor is reputedly the oldest house in Yarmouth, built in 1821. The current occupants moved from Monaco and opened its doors (and windows) as an arts and culture house. There is an art gallery and café inside the house, and to-go crepes are served out of a window. This "to-go" culture is more prevalent in the fast food joints on nearby Starrs Road, but here the old and the new sit side by side.

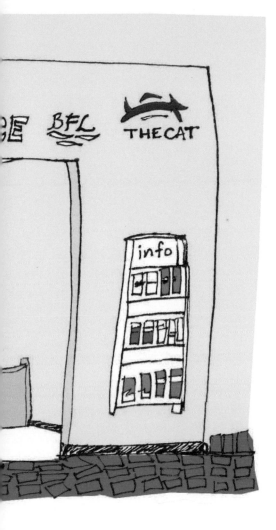

"Looking for a ferry ride? Tomorrow is our last day of service, then we are closed for the season."

The CAT ferry provides daily service between Yarmouth and Maine, and is a conduit for many of the American tourists who visit the area during the summer months.

"What are you going to do when the season ends?" I ask.

"Oh, I'll be working a few jobs, and studying coding."

WINTER

Winter appears here as sort of an epilogue. In early winter, there are still festive activities happening in the lead up to Christmas. Then winter deepens, snow storms take full hold of the landscape and people tend to be at home. It was not the best environment in which to sketch on location! Nonetheless, I made it down the South Shore to partake in some of the festive cheer, and experience the raw landscape that makes the shore worth visiting even in the coldest months of the year.

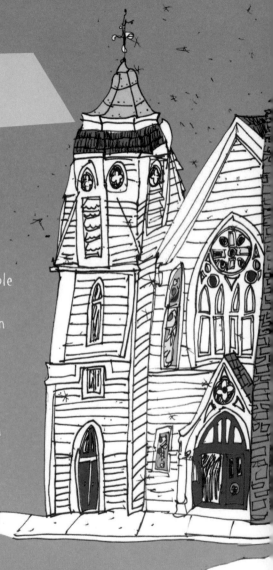

Sounds of singing come from various churches, and decorated Christmas trees circle the gazebo. Lunenburg loses its busy tourist town feel in the winter, but seasonal holidays bring a festive buzz.

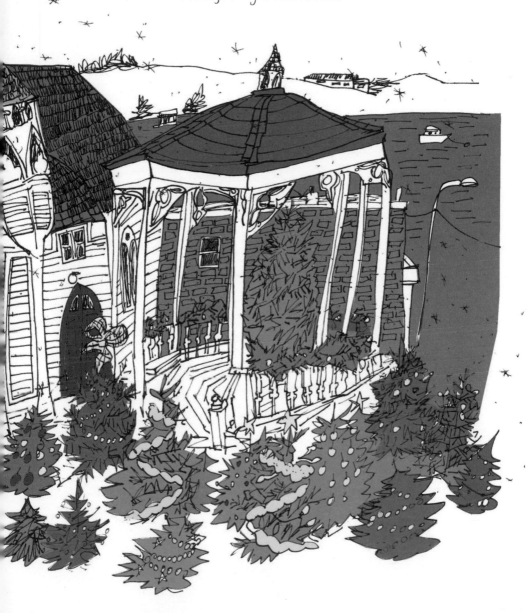

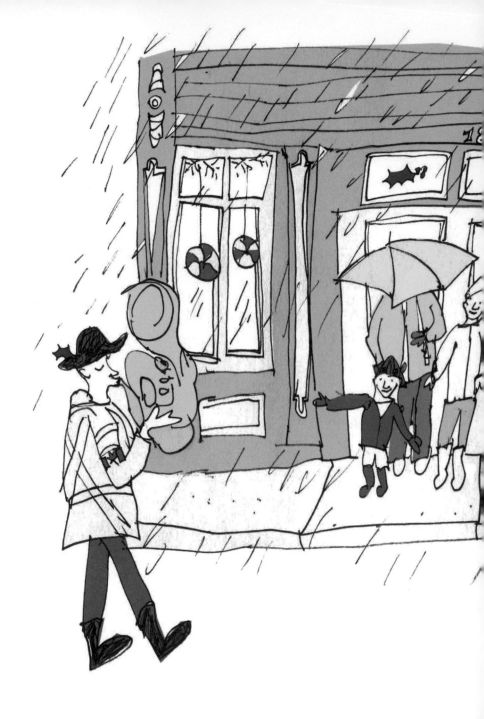

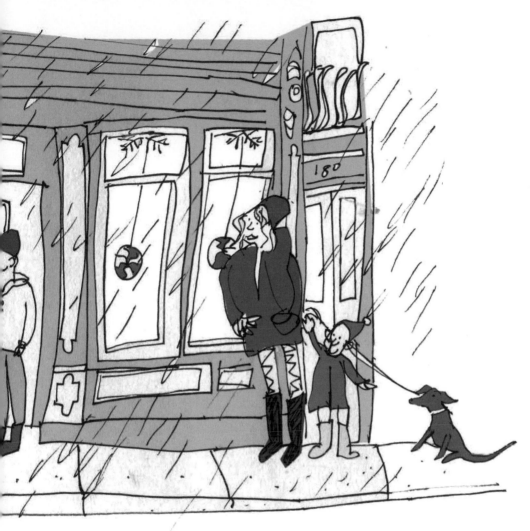

Rain pelts down on the annual Lunenburg Santa Claus parade,
but families brave the weather, lining Lincoln Street in rubber
boots and raincoats.

Beside me I hear, "Do you think we have time to cross the road?
The band is coming!"

"Let's cross! We'll be part of the parade."

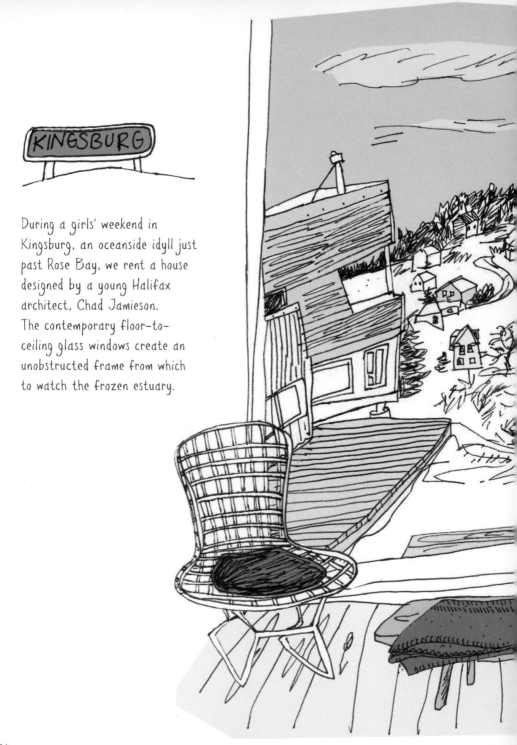

KINGSBURG

During a girls' weekend in
Kingsburg, an oceanside idyll just
past Rose Bay, we rent a house
designed by a young Halifax
architect, Chad Jamieson.
The contemporary floor-to-
ceiling glass windows create an
unobstructed frame from which
to watch the frozen estuary.

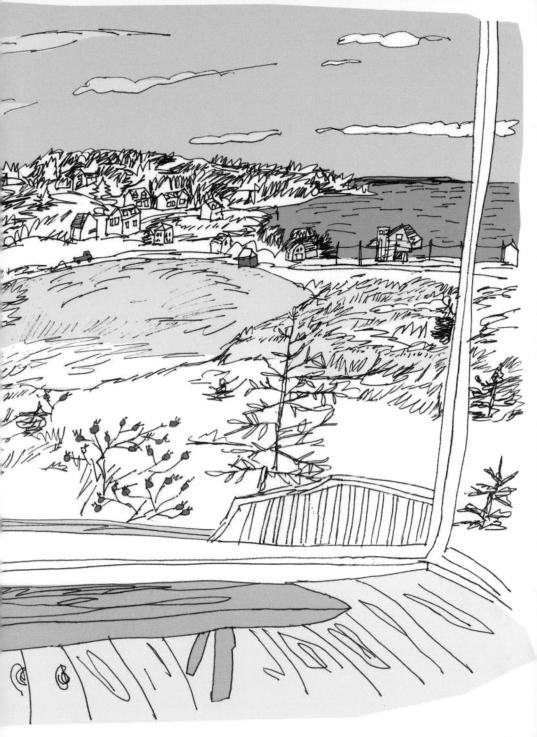

Sunday morning brings a storm. The roads are impassable as driving wind has created snow drifts several feet high. We don't mind, as long as there is wood for the fire. A neighbour comes by with her dog, Guinness, who bounds through the snow, black fur dancing on white.

"They will be coming to clear the road. We don't know when, but they are coming."

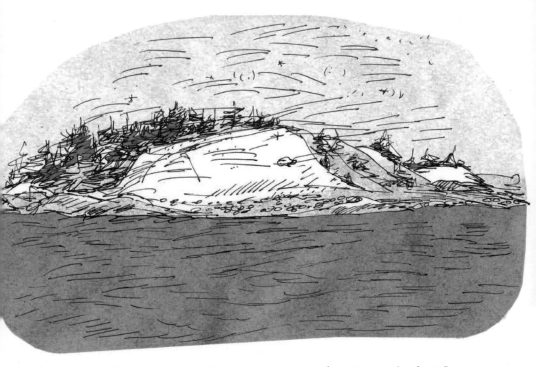

Eventually we leave the house. We make it to the head of the nearby Gaff Point hiking trail, after stumbling over ice-laden rocks on Hirtles Beach. A wooded trail loops to the point and provides a view of West Ironbound Island, where sheep graze year round. In the summer they feed on grasses, and in the winter they eat seaweed. But on storm days they stay huddled among the spruce trees, and are not visible from the shore.

As we look out towards this lonely landmass, I dig my hands deep into my pockets and breathe the sharp, cold air. I am content, knowing that the seasons will change. The island will become green again, and my eyes will see its colours all the more for their absence in winter.

GAFF POINT

Acknowledgements

I offer my thanks to the entire team at Formac Publishing for their continued dedication, talents and energy. I worked closely with Jim Lorimer, Jenn Harris, Laura Cook and Tyler Cleroux; I am grateful for their help shaping the book you see here.

My family and friends, near and far who have supported me with so much love as I find my way — thank you!

Thanks to the Lunenburg School of the Arts for hosting me as a teacher during their summer programming, and to the Salt & Honey Residency at Red Clay for giving me time and space to work on the manuscript.

I extend a sincere thank you to those who shared the stories that appear on these pages, and my apologies for any misinformation. I accept full responsibility for any mistakes that may appear. Thanks to Gaspereau Press and poets Sue Goyette and George Elliott Clarke for permission to use their words.

As I don't drive or have a fixed address on the South Shore, this project could have been impossible. Instead, it was made easy thanks to the generosity of the following people: Catherine MacQuarrie and Karl Marsters, Katherine Marsters, the entire Marsters/MacQuarrie extended family, Rosalyn Iuliucci, Josh Collins, Bob Iuliucci, Betsy Hart, Doug Bamford, Natasha Warren, Claire Poirier, Rod Malay, Cat Crocker, Siobhan Wiggans and Saoirse Forsythe, Trish, Jeff, Laura and Mark FitzGerald, Catherine Young, Anne Sinclair Architect, Desmond Cole, Charles Officer and Canesugar Filmworks, Krista Holman, Arianna Williams, Rob Cameron, Johanna Steffen, Lisa Cochrane, Jane Mitchell, Erin Mooney Robison, Cloé Landry-Thibault, Mustapha Addahar, Christine Finley, Sam Bambrick and Alternative Routes, Emma Boardman, Sue Bone, Katie Belcher, Rose Zach, Martha Cooley, Christina Gunn, Savayda Jaronne, James Forren, Jacob Jebailey, Maria and David Gallaugher, Ouna Gothanng, Sash Koirala, Claire Stewart . . . And an ever-rippling circle of people whose help was invaluable.

David FitzGerald, come visit soon!